CAMERA CRAZY

© Prestel Verlag, Munich · London · New York, 2014
© for the texts by Buzz Poole and Christopher D. Salyers, 2014
© for the photographs see Image Credits (page 239), 2014

Front cover: photos © J. K. Putnam except for Bigshot © Shree K. Nayar
Back cover: photo © J. K. Putnam

Prestel Verlag, Munich
A member of Verlagsgruppe Random House GmbH

Prestel Verlag
Neumarkter Strasse 28
81673 Munich
Tel. +49 (0)89 4136-0
Fax +49 (0)89 4136-2335

www.prestel.de

Prestel Publishing Ltd.
14—17 Wells Street
London W1T 3PD
Tel. +44 (0)20 7323-5004
Fax +44 (0)20 7323-0271

Prestel Publishing
900 Broadway, Suite 603
New York, NY 10003
Tel. +1 (212) 995-2720
Fax +1 (212) 995-2733

www.prestel.com

Library of Congress Control Number: 2014936647

British Library Cataloguing-in-Publication Data: a catalogue record for this book is available from
the British Library; Deutsche Nationalbibliothek holds a record of this publication in the Deutsche
Nationalbibliografie; detailed bibliographical data can be found under: http://dnb.d-nb.de

Prestel books are available worldwide. Please contact your nearest bookseller or one of the above
addresses for information concerning your local distributor.

Editorial direction: Ghost & Company, LLC

Design and layout: Ghost & Company, LLC
Production: Friederike Schirge
Origination: Reproline Genceller, Munich
Printing and binding: Neografia, a.s.
Printed in Slovakia

ISBN 978-3-7913-4955-8

FSC
www.fsc.org
MIX
Paper from
responsible sources
FSC® C020353

Verlagsgruppe Random House
FSC® N001967
The FSC® -certified paper
Profimatt has been supplied by
Igepa, Germany

CAMERA CRAZY

CHRISTOPHER D. SALYERS & BUZZ POOLE

PRESTEL

MUNICH · LONDON · NEW YORK

CONTENTS

TOY CAMERAS: MARKETING A MEDIUM AND THE AUTHENTICITY OF THE UNEXPECTED
BUZZ POOLE

When Susan Sontag wrote that photography's "main effect is to convert the world into a department store or museum-without-walls in which every subject is depreciated into an article of consumption, promoted into an item for aesthetic appreciation," she most certainly was not thinking of toy cameras. But the sentiment aptly applies to this photography industry niche and the deft marketing strategies implemented to shift the perception of photography from being an expensive professional's pursuit to an affordable, everyman's activity.

Not only were the earliest cameras expensive, they were large and the creation of an image required time and knowledge. As cameras were refined and made smaller and more efficient they were marketed to appeal to hobbyists. No longer was photography defined by long spells of sitting in portrait studios or the lugging around of bulky cameras, fragile plates, and corrosive chemicals. Photography became an off-the-cuff novelty, capturing candid family moments and scenes of leisure.

The evolution of photography from being a rarefied medium to something so commonplace we hardly even think about it anymore has as much to do with savvy marketing as visual aesthetics and artistic practice. From the very early days of photography, camera manufacturers tapped in to popular culture trends in order to promote, and package, their cameras.

An indispensable resource for understanding the genesis of toy cameras is John Wade's slim but detailed *Cameras in Disguise,* which charts a clear trajectory from "disguised cameras," made as early as 1862, to the toy cameras of today. As Wade sees it, in the United States, as well as in Europe, the public was interested in everything about detectives, especially their covert ways. Whether it was Pinkerton's National Detective Agency in the United States, which started in 1850, or the publication of the first Sherlock Holmes story in 1887 in the United Kingdom, both real and fictional detectives were curiously popular.

In 1862, an English designer known only as Thompson, working with A. Brios in Paris, received a French patent for a Revolver Photographique. Compared to the cameras made to look like pistols and rifles that would follow in its wake, this first revolver camera really only looked like a firearm in that it had a wooden handle similar to one that would be found on a pistol, and the lens resembled the barrel of a gun.

Up until this time, cameras used wet plates, which required chemical preparations prior to an exposure and then needed to be developed immediately after the photograph was taken. As Wade points out, the advent of dry-plate technology permitted photographers to shoot an exposure and develop it at another time, giving designers of disguised cameras much more flexibility.

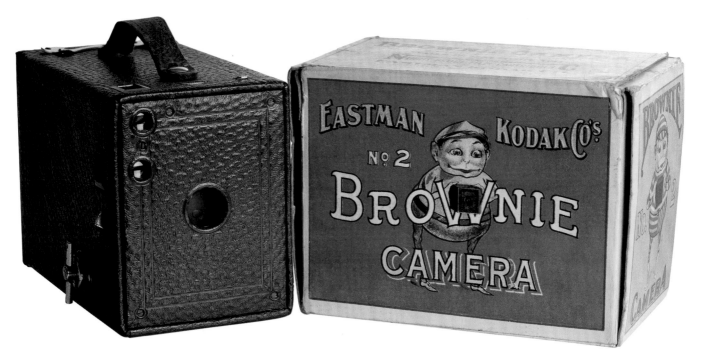

The Eastman Kodak Brownie Camera, Model No. 2.

An impressive array of disguised cameras was made during the last two decades of the nineteenth century; it is also worth noting how several of these cameras incorporated technological developments that went well beyond outward appearances. In 1882, Etienne Jules Marey made a Gun Camera, not to be secretive about his taking of pictures but to better aid him in his scientific study of birds in flight. According to Wade, the camera "housed a long focus lens in the barrel that acted as a telescope to enlarge distant objects. A large circular dry plate was housed in a special magazine and as the gun's trigger was pressed a mechanism revolved the magazine to expose twelve pictures in rapid succession." The following year, the Photo-Revolver de Poche, designed by E. Enjalbert, used parts from a real revolver, looking almost identical to a European gun from that era.

More and more patents followed and with them new ideas for cameras that didn't look like cameras. E. Enjalbert also designed the Postpacket Camera, which looked liked a wrapped parcel. As Wade writes, "Models were also launched disguised as binoculars or opera glasses, with one lens for the exposure, the other for the viewfinder. Others appeared disguised as handbags, and there was even one made to look like a picnic basket." Cameras were hidden behind vests and inside men's hats; in 1890 Bloch's Photo Cravat hit the market. Books became a popular disguise for cameras, often housing the lens in the spine.

Individual inventors and tinkerers developed many of these cameras in disguise, and their proliferation indicated a demand for cameras marketed to consumers

who did not identify themselves as photographers. George Eastman, already holding patents for crucial elements of photographic processes, such as film and film roll holders, recognized the potential for such cameras. According to Eastman biographer Elizabeth Brayer, a patent was issued in 1886 for the Eastman Detective Camera, which was inspired by the 1883 release of the first commercially produced hand-held box camera invented by William Schmid of Brooklyn, New York. In June of 1887 fifty of Eastman's detective cameras, set at a retail price of $45 USD, were ready to be released on a trial basis. For reasons not wholly known, Eastman distributed only a handful of these trial cameras, presumably retraining his focus on the development of the first Kodak, and its release in 1888.

Of course, the first Kodak changed photography, and in truth human culture, bringing the medium to the people. The logo promised: "You press the button—we do the rest." It was an ingenious model in how it empowered people to be excited about taking pictures and as a result of that excitement insured that the entire range of Kodak photographic accessories—from cameras to film and processing fees—would always be in demand.

In 1900, Kodak introduced the Brownie camera, the launching pad for the toy cameras featured in *Camera Crazy*. Using Palmer Cox's illustrated "Brownies"—beetle-like sprites that were already popular culture fixtures—the Brownie was marketed explicitly for children.

As mainstays of American popular culture since 1883 these mischievous but moral characters borrowed from Scottish folklore had already been on ample adventures before teaming up with Eastman Kodak. Jeanne Solensky, a librarian in the Joseph Downs Collection & Manuscripts & Printed Ephemera at the Winterthur Museum in

Delaware, writes at the museum's blog: "Throughout, the Brownies were on the cutting edge of trends, engaging in sports like bicycle-riding and tennis, riding cars, and visiting the Brooklyn Bridge and the 1893 Columbian Exposition in Chicago even before the fair opened." Popular? Adventurous? Trend setting? What better spokespeople could there be to try to convince every family in the world to buy a camera? Of course, leveraging the popularity of one brand to help promote another was nothing new. In fact, the Brownies had lent their hippy, spindly-legged likenesses to all sorts of products:

> By the 1890s, the Brownies could not be confined to the printed page and burst into the advertising and merchandising worlds as companies sought to ride the Brownie wave to increased sales. Small Brownie paper dolls were placed in packages of Lion Coffee and the New York Biscuit Co., prompting children to beg parents to buy more to collect entire sets. A band of Brownies playing musical instruments paraded across trade cards for Estey Organ Co. Twelve characters were fashioned into seven-inch cloth toys manufactured by Arnold Print Works of Massachusetts, a very successful dress goods printer. The Brownies transformed into rubber stamps, card games, blocks, puzzles, and even bowling pins. They even appeared on household furnishings like carpets, wallpaper, fireplace sets, china, glassware, flatware, and of course, Kodak cameras. The Brownie empire reigned.

The first model, known as No. 1 Kodak Brownie—an eight-ounce, palm-sized box camera with the capacity for six exposures and four square pictures, without reloading—retailed for $1 USD. The carrying case cost an additional fifty cents. According to Kodak, 150,000 Brownies were shipped out in the first year alone, far exceeding expectations.

Attracting kids with the cute characters they recognized from comics, and appealing to parents as a cheap and easy-to-use camera that their child could play with, Kodak capitalized on a cross-promotional marketing scheme that only became more dynamic with every new model. By 1933 Eastman Kodak forged marketing alliances that resulted in the Boy Scout Brownie and the Century of Progress Brownie, an official souvenir of that year's World's Fair. Throughout the twentieth century, as the popularity of photography skyrocketed, this approach to marketing photography would only become more sophisticated, making the medium big business.

How big a business? Between 1948 and 1953, Polaroid sold 900,000 Model 95 Land Cameras, the first commercially available self-developing instant camera. While Polaroid cameras were not toy cameras (though several toy Polaroid cameras were manufactured over the years) this impressive sales figure makes clear that cameras were in demand, giving camera companies plenty of incentive to promote their products in every imaginable manner. It is no surprise, then, that camera makers and companies that had nothing to do with photography partnered to promote their respective products.

Photography started as a scientific art but the insistence on the part of Kodak, and the companies that have followed it, that photography should be fun and easy blurred the line between "serious" photography and "recreational" photography. All because of the marketing of a toy, that happened to be a camera.

In his essay "The Philosophy of Toys," Charles Baudelaire recounts a childhood trip to a mansion where a woman of means, wanting to give him a memento of his visit, takes him to a room where "the walls were invisible, so deeply were they lined with toys. The ceiling had vanished behind a great towering bouquet of toys, which hung down like wonderful stalactites. The floor barely afforded a winding path for one's feet. Here was a world of toys of every kind, from the costliest to the most trifling, from the simplest to the most complicated." If it were possible to install every toy camera ever made in a single room, it would be as colorfully jumbled as the room Baudelaire describes.

What are we to make of all these nontraditional cameras that fill the pages of this book? They all are functioning cameras in that they are capable of taking pictures. Some were created to do nothing more than promote a brand. Some were created for specific reasons but became popular for unintended reasons. Some seem to fall into both categories. And here they all are: cute and cutting edge; clunky and junky; hokey and vintage. They all share one thing in common, however—they are all toy cameras.

Baudelaire places great importance on toys because they instill the "facility for gratifying one's imagination." He doesn't understand the parents who do not permit their child to play with a toy because it is too nice for the child, and he laments the child who prefers to preserve her toys, as if they are part of a museum collection, rather than use them to have fun. Baudelaire insists, "toys become actors in the great drama of life, scaled down inside the *camera obscura* of the childish brain." For the purpose of *Camera Crazy*, this is an extremely fitting quotation. For Baudelaire's purpose, *camera obscura* refers to a child's mind as a dark chamber awaiting imagination to fill it with the colors of life. But writing this piece in 1853, he doubtless also had in mind the medium of photography and its genesis in the ancient *camera obscura*, that seemingly magical phenomenon of light passing through a tiny aperture into a dark room and projecting onto the wall an inverted image of an object outside the room.

At its core, photography is the act of collecting images. Why shouldn't it be playful? For a long time, this was not the case, however. But after the success of the Brownie, all of that changed. When Baudelaire wrote, "The toy is the child's earliest initiation into art, or rather it is the first concrete example of art," no one thought of cameras as playthings. Only trained professionals used them. But by the twentieth century this was no longer the case and different schools of photography emerged, most simply divided between professional and hobbyist. There were photographs worthy of hanging in museums and snapshots only suitable for family photo albums.

This split actually began near the end of the nineteenth century when members of longstanding photographic societies parted ways in an international wave of "photo-secession," forming new groups dedicated to securing photography's status as an art form as important as painting. By this time, no matter how divisive opinions regarding the medium, there was no shortage of potential customers for the photography industry. The industry just needed to understand the consumers they were trying to reach.

But then something curious happened—everything blurred and the clarity of distinction between professional artists and everyday hobbyists dissolved, leaving a bokeh of camera enthusiasts.

In 1973, when Walker Evans first started playing around with his first Polaroid camera, he famously referred to it as a toy. But it was the toy he favored for the rest of his life, finding his subjects "all strangely enhanced by the technical limitations of the camera." After World War II, photographers like Garry Winogrand and Lisette Model came to the fore of the art world for their candid street photography. More and more, aesthetic standards were shaped by the authenticity of the unexpected. No matter what side of the camera people were on, they wanted to see, make, and take part in images that they could relate to, cataloging, in the words of Evans, an "inventory of American memory," or the memory of the human experience. It didn't matter if the composition of the shot was perfect, or if the lightning was right, or if the colors on the print were a bit washed out. Life is all about the unexpected and photography learned to embrace this fact, and profit from it.

All of the cameras in this book were borne out of promoting fun and imagination, very much in line with why Baudelaire so valued toys. Yes, it is in the name of selling product, but these cameras make users forget that, even when they are holding something as garishly branded as a beer can camera. Holga, Lomography, SuperHeadz, and the smaller companies making equally exciting toy cameras, prioritize a user experience that is about fun and being in the moment, the opposite of the time when photography was a slow, expensive process.

The cameras are quirky, sexy, silly, plain, and audacious, reflecting their users and permitting them to be comfortable with how the medium has changed so dramatically, and making sure they realize how they are active participants in this change.

It is easy, and fair, to be critical of how the proliferation of photography has forever changed our relationship with the image and how the image informs perspectives of reality. This is what Susan Sontag called to attention in the essays that comprise *On Photography*. Her concern was how the ubiquitous photograph had become a stand-in for reality: "Photos, rather than the world have become the standard of the beautiful." This, as Sontag saw it, demeaned photographic subjects, treating

them like nothing more than objects to be consumed. To be sure, if you agree with what Sontag identified as problematic about the popularity of photography, the question deserves that much more scrutiny since the advent of digital photography and the accelerated modes of image delivery and sharing.

What Sontag decried, the companies and cameras featured in *Camera Crazy* celebrate, though not in the name of the mindless consumerism suggested by Sontag's "department store" world. These cameras are the kinds of toys Baudelaire so admired, embodying the whimsy of materialism and its inherent frivolity that nonetheless yields stunning results. The results might not hang on museum walls, sell for huge sums in sterile galleries, or be included in surveys of art. But then again, plenty of images made by toy cameras have done such things. The "toy" in "toy camera" is a tool for the imagination, whether in children or adults, self-identified artists or proud amateurs, reminding us all of the importance of not over thinking and not taking everything too seriously. These cameras invite us to treat the world like the toy-choked room that left an indelible impression on the young Charles Baudelaire, where the whole photographic process is a matter of playing, from selecting the camera to choosing the shot and looking at the image. We should all be so lucky to surrender, in Baudelaire's words, to "that admirable and luminous alacrity which is typical of children, in whom desire, deliberation and action are so to speak compacted into a single faculty—and which sets them apart from degenerate man, almost all of whose time is on the contrary eaten up with deliberation."

The unwavering popularity of toy cameras is deliberate to be sure. But that is in large part due to the cameras being made and marketed for users who want to shirk deliberation, preferring to indulge desire and ego. In 1859, in the June issue of *Atlantic Monthly*, Oliver Wendell Holmes, Sr. dubbed photography a "mirror with a memory." When I look in the mirror, I do not see the same face that someone looking at me sees, or the same one portrayed in a photograph. As Holmes rightfully pointed out, photography documents the fabrications of memory. All cameras encourage people to capture the stories of their lives, not quite as they happened, but how the user makes viewers believe that is how they happened. Toy cameras and the images they produce unapologetically call attention to the schism between object and image, letting us forget about mimetic principles and shutter speeds to enjoy the simple act of creation, triggered by an individual who wants to add something new to the world.

IT'S NOT THE PHOTOGRAPHER, IT'S THE CAMERA: A BRIEF HISTORY OF THE MODERN TOY CAMERA
CHRISTOPHER D. SALYERS

UNLIKELY BEGINNINGS

The history of the modern toy camera starts in the early 1960s, with a small company in Kowloon Bay, Hong Kong, called the Great Wall Plastics Factory. It is here that they created the Diana—a lightweight, extremely cheap (at the time of production, less than $1 USD), plastic-bodied 120 film camera with a plastic lens. It had one shutter speed, three aperture settings—sunny, sun with clouds, cloudy—and manual focus from 1m to infinity. And cheap it was: the shutter release caused a loud cracking noise, and the film winding sounded forced and fragile as it chattered with each turn. The Diana also suffered terrible light leaks, and many resorted to covering the body in multiple layers of gaffer tape.

It was imported to the US by the Power Sales Company of Willow Grove, Pennsylvania, and wholesaled by the case (144 cameras) at around fifty cents per unit—and though this original Diana experienced success as an inexpensive export, production at Great Wall ceased in the mid-'70s. In part, their failure can be attributed to the Chinese market, which was flooded with clones. These copycats had a wide variety of altered features, including electronic flashes, longer lenses, fake light meters, and extra shutter speeds. They also each had their own take on the "Diana" logo that encircled the lens: "Snappy," "NorthAmerican" (page 102), "Sam Toy," "Mego Matic," "Candy," and "Acme," to name a few.

The Diana challenges the photographer to see beyond the equipment and into the image.... [It] summons up the Dadaist traditions of chance, surprise, and a willingness to see what can happen.
—Robert Hirsch, *Photographic Possibilities*

The Diana had an artistic appeal all its own, and arrived at a time when unconventional photography was being recognized by galleries and institutions. When photographer Nancy Rexroth discovered the Diana in a graduate class at Ohio University in 1969, it immediately struck a chord. The images she was able to create with this cheap plastic camera evoked a mysterious and dreamlike exploration of her own childhood. With Rexroth's *Iowa* in 1971, the Corcoran Gallery in Washington, DC, held the first major exhibition of photography shot with a Diana. Subsequently, Violet Press's 1977 publication of *Iowa* was the first monograph of images taken with a toy camera.

The Friends of Photography gallery in Carmel, California, held a juried exhibition in 1979 titled *The Diana Show,* where more than one hundred participants submitted photographs shot with a Diana. The show's catalogue includes the first major essay on the toy camera, "Pictures through a Plastic Lens," in which The Friends of Photography's Executive Associate David Featherstone wrote:

In a medium so deeply rooted in the technology of its making, it is not surprising that many photographers reach a point of technical confinement which must be overcome in order for their personal creative growth to continue. The conflict is resolved in many ways; explorations of alternative print-production processes and major changes in subject concerns are examples. The search for visual spontaneity through use of a simple camera such as the Diana is yet another.

Questions about what constitutes professional or artistic photography were quite prevalent at the time, with Ansel Adams famously quipping that the technical obsession with the photographic process created a "sharp image with a fuzzy concept." The toy camera is a direct response to this. The "confinement" perceived by Diana users at the time carries over into the digital age, as the technical aspects of each new and improved digital camera may seem daunting to the aspiring photographer.

By the end of the '70s, the Diana had become scarce—even production of its clones was dwindling. Collectors and enthusiasts scoured flea markets and thrift stores hoping to stumble upon an original. Yet, unaware of the toy camera movement growing in the United States, Hong Kong entrepreneur T.M. Lee created what was to become the Diana's spiritual successor: the Holga.

In the late '60s, Lee began his career at Yashica. Not long after, he formed his own company, Universal Electronics Industries, where he achieved initial success making flashes for cameras. But as the '70s market moved toward built-in electronic flashes, he was forced to rethink his business model. The first medium-format camera with a built-in flash, the Holga was released in 1981. (The name is an Anglicization of the Cantonese phrase *ho gwong*, meaning "very bright.") Like the Diana before it, the Holga

WHAT IS A TOY CAMERA?

A toy camera—typically—is a simple plastic box camera with fixed focus, limited aperture settings, and (in most cases) a single shutter speed. Toy cameras have unique and sometimes unpredictable characteristics that define them, such as light leaks, vignetting, and soft focus. Though the term is ever-changing and often argued about in enthusiast circles, most of the cameras in this book are toy cameras. Some may not be inexpensive; some may have electronic shutters; and some may be digital; but the most important aspect of the toy camera is the unexpected fun you can have with it.

was prone to malfunctions and produced results that appeared impressionistic or surreal. At the time of its inception, the Holga was made for 120 film, but just a few years later 135 took over in popularity across China. So it was in the United States that Lee found his niche market, where sales soon reached 10,000 units per year (today, that number is somewhere around 200,000). First adopted as a low-tech instructional tool for institutional workshops, the Holga is now internationally recognized as a creative, unconventional camera for photographers looking to stand out against a digital norm.

NOVELTY TOY CAMERAS

The Diana may have been the frontrunner of the toy camera movement, but it wasn't the first. Throughout the '50s and early '60s, a variety of "toys" were manufactured as compact beginners' cameras. (These included, but were not limited to, the Ansco Panda, the Brownie Holiday,

the Coronet 4-4 Mark II, the Fujipet, and the Imperial Mark XII.) The retail model changed in 1963, when Kodak released their Instamatic line of point-and-shoot cameras alongside a new, easy-to-load, cartridge-based film: the 126. Now that the backing plate and exposure counter were built into the cartridge itself, this allowed for simpler and cheaper cameras to be produced.

With budgets lowered, some truly bizarre novelty cameras were released for 126 film. Disney has seen their characters branded onto many different toys, but in 1971, Child Guidance Products of the Bronx, New York, released the Mick-A-Matic (page 20). What made this unique wasn't the fact that it was a Mickey Mouse camera, but that the camera *was* Mickey Mouse: a lens for a nose, a viewfinder

for a forehead, and (in early models) an ear that acted as the shutter lever. (A label on the back of his right ear reads: "Treat me gently, I'm your pal.")

Similarly strange is Whitehouse Products' Brooklyn-made Charlie the Tuna 126 camera (page 22), released in 1971. In exchange for three StarKist can labels and $4.95 USD, you could own your very own oversized (241 mm tall) tuna-shaped camera, complete with his signature thick-rimmed glasses and red cap. As the original ad stated: "Just give 'em the old fish eye—they'll never know it's a camera."

In 1972 Kodak released a more compact version (13×17mm vs. 28×28mm image size) of its 126 film: the 110. This format was extremely popular at launch and led to the production of a wide variety of novelty cameras over the next two decades. Cameras were released disguised as cigarette packs, cans of soda or beer (pages 64–67), a car tire (page 68), a miniature airplane (page 70), *Webster's Dictionary* (page 84), a He-Man toy (page 36), and even a bag of French fries (page 60).

The production of toy cameras saw a decline in the late '80s and '90s, largely due to the popularity of inexpensive single-use 135 disposable cameras. Though iterations of disposables have existed since 1949, the first truly successful disposable was Fujifilm's Utsurun-Desu (translation: "It takes pictures") released in 1986. Kodak released its version, the Fling ($9.95 USD), in 1987, which was later rebranded the FunSaver in 1989. Versions of cheap disposable cameras found their way into just about every retail outlet, catering to the growing need for immediate, simple, and inexpensive photography at a time before cell phone technology placed a camera in everyone's pocket. Still, the nostalgia factor for these cameras is growing, and—like in notions of lost art or

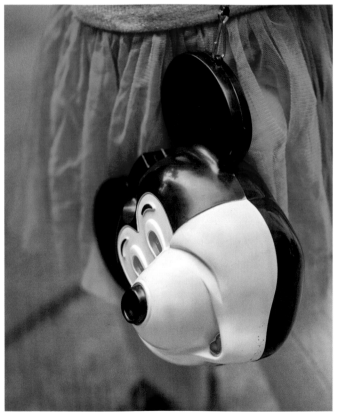

The Mick-a-Matic camera.

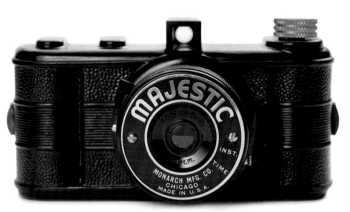 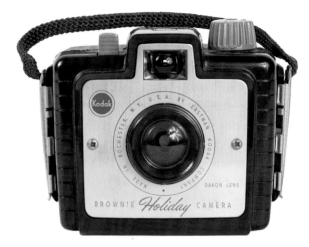

⊙ The Majestic and the Brownie Holiday served as inspirations for modern day toy cameras. Compare these images with the Sprocket Rocket (page 153) and Golden Half (page 204).

shared experiences, where cameras are left for strangers to use—many artists are finding new ways to experiment with single-use cameras.

Though toy cameras were still being produced (for mostly 135 film) with interesting designs and quirky, in-camera effects, they were mainly marketed toward children. Throughout the '80s, '90s, and early 2000s, there were brand tie-ins such as Barbie (page 58), Star Wars (page 50), Teenage Mutant Ninja Turtles (page 44), Hello Kitty (page 56), and Pokémon (page 52). Then there were oddities like the Nickelodeon Photo Blaster, which captured four images per frame yet had, quite possibly, the ugliest camera design ever produced. In 1998 Nintendo released the Game Boy Camera (page 226), which at the time was the world's smallest digital camera (*Guinness Book of World Records*, 1999). Though crude in result (256×244 pixels [0.014MP], black-and-white, thermal-paper printing), the camera was innovative in concept, with a rotating lens allowing for front-facing "selfies" that could then be used interactively on built-in

games or edited in-screen—features now common on just about every modern handheld device.

TWENTY-FIRST-CENTURY TOYS

Like in many art scenes, the toy camera had its own movement: Lomography. The Lomography Society was founded by a group of Viennese students in 1992, after they became enamored with the image quality captured by the 1984 Russian-made compact point-and-shoot camera, the Lomo LC-A. Far from a cheap plastic camera, the LC-A was made of metal with a quality Minitar 32mm lens. Many international photography exhibitions later, Lomography has become synonymous with toy cameras, opening showrooms worldwide and releasing their own variants on the plastic toy camera (Supersampler, Fisheye, La Sardina) and re-creations of classics (including the Diana and Holga) every year.

With the advent of the new millennium, the concept of the toy camera shifted into the digital realm, thanks in large part to novelty cameras (many Japanese-produced) and

phone apps (like Hipstamatic) that re-create the effects of many popular plastic-bodied box cameras. Instagram, a Facebook-owned camera app with social media functionality, has the ability to take normal, low-resolution photographs and tweak them using various filters to give photos a retro, hazy, analog-like appeal. You might Instagram the cover of this book, for example, quickly choose a filter you like, and not think much on it before sharing the image with your friends. But what you've really done is digitally mimic the results of a vintage camera. The Lomo LC-A, Yashica Mat, Diana, Holga, and Polaroid are all inspirations for these filters.

The Japanese company SuperHeadz (and its parent company, Powershovel) creates cameras that fully embody the modern spirit of the toy camera—inventive, unique, and fashionable. Its Harinezumi (page 191) digital camera, with the appearance of a tiny roll of 110 film, shoots video and stills that have the quality of an aged roll of 8mm. It's Wide and Slim line (a reimagining of the cult classic Vivitar Ultra Wide and Slim, page 206) is popular for its 22mm focal length and results that are unnaturally vivid, with oversaturation and high contrast. The Super-Headz Golden Half looks like a modern, compact take on the Kodak Brownie Holiday camera—except it takes two shots per frame. Like other multiframe cameras, there's a playful interaction with the subject(s) as you consider not only the image in the frame, but the next shot, and how the two will relate side by side. The Blackbird Fly (page 196), one of their more recognizable cameras, is an all-plastic modern twin-lens reflex in a variety of bold colors that is sold in a faux plastic birdcage.

Camera crazy: the ever-growing pile of plastic.

Another Japanese maker, Fuuvi, takes a more whimsical approach to their products, with even more digital offerings: a biscuit-shaped camera (pages 214–15), cameras that look like glasses, and more. Each is made to look like a novelty accessory and produces images that mimic analog-like effects.

With photography's much publicized—and once scorned, then ultimately embraced—move into digital, the way we see and interact with the medium has changed. No longer is photography an art exclusive to tech junkies. From Lomography to iPhoneography, it's clear that the age of the point and shoot as mainstream art is upon us—either that, or we're still all rebelling against the barrage of high-definition media.

> It is the person behind the camera, rather than the machine itself, who created the image. This at least is one of the paradigms of creative photography.
> —David Featherstone, *"Pictures Through a Plastic Lens"*

Many of us tend to think of the camera, not the photographer, when we view certain images, and this is a significant change in how we interpret the medium. Thanks in large part to the Internet, more people than ever perceive the camera as a specific filter to certain aspects of their lives. You might take a Diana to your friend's wedding, bring a Fisheye to the beach, color tint your online profile picture, or take your Holga on a sightseeing trip around town—each with a particular look or style in mind. We're constantly battered by imagery, and the more we interact with them via apps, social media, or simple online image sharing, the more we understand how they're made and which camera/filter/lens they came from. Whether or not you can tell the difference between a digital filter and an analog original, well, that's a whole other matter.

The toy film camera, in the simplicity of its form and the charm of its weaknesses, creates images that are unexpectedly personal. They act as a third-eye vantage point on life's chosen moments, seeing things as the photographer cannot. Toy cameras are, perhaps, the simplest ways to keep the spirit of film photography alive. Beyond the rhetoric and rules, they lend a romantic interpretation of the world, a mysterious way in which they make marks with light. They're quirky, inventive, and unconventional. They allow us to look at the art of photography with all the vibrancy and excitement of youth—for they are, after all, toys.

NOVELTY CAMERAS

MICK-A-MATIC

Manufactured in USA for Child Guidance Products Inc. Year: 1971. Film: 126. Flash: flash cubes.

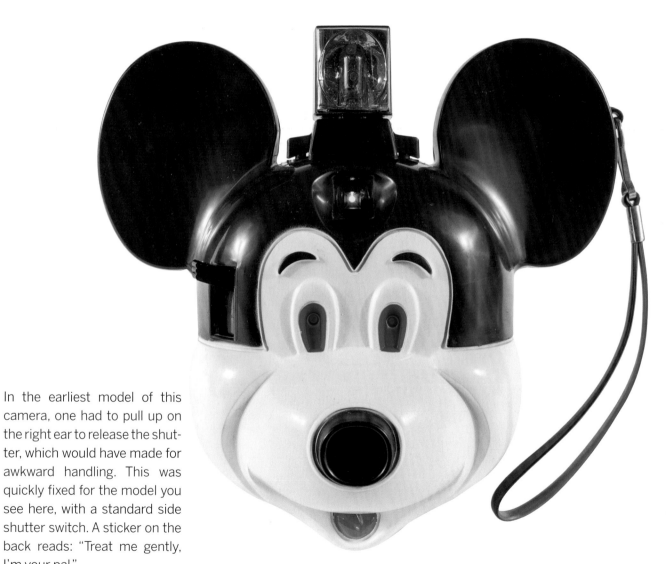

In the earliest model of this camera, one had to pull up on the right ear to release the shutter, which would have made for awkward handling. This was quickly fixed for the model you see here, with a standard side shutter switch. A sticker on the back reads: "Treat me gently, I'm your pal."

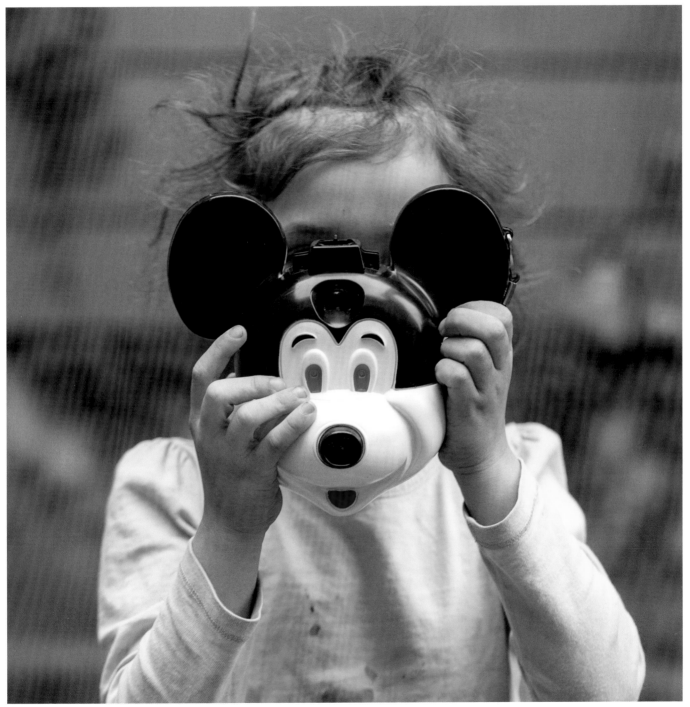

Sylvie frames her shot with the Mick-a-Matic.

CHARLIE TUNA CAMERA

Manufactured in USA (Whitehouse Products, Brooklyn) for StarKist. Year: 1971. Film: 126. Flash: flash cubes.

Available for just three StarKist tuna labels and $4.95 USD, this unique camera was a mail order exclusive. The ad inside *Good Housekeeping* magazine stated: "Just give 'em the old fish eye—they'll never know it's a camera."

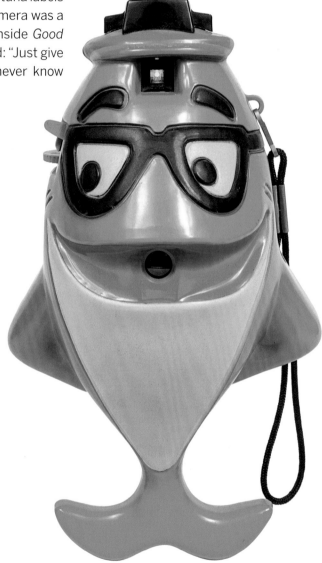

SNOOPY-MATIC

Manufactured in Hong Kong for Helm Toy Corp. Year: 1980. Film: 126. Flash: flash cubes.

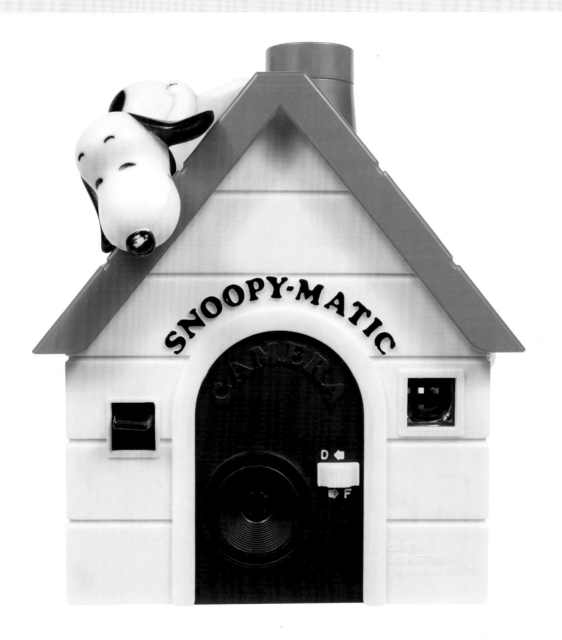

BUGS BUNNY CAMERA

Manufactured in Hong Kong for Helm Toy Corp. Year: 1976. Film: 126. Flash: flash cubes.

Bugs Bunny and the rest of his Warner Brothers gang have been popular culture icons since they were first introduced in the late 1930s. There probably isn't a toy or item of apparel that hasn't been branded with Bugs, Daffy, and Porky. But it is worth noting that cameras and Looney Tunes have a longstanding history. In the 1940 Merrie Melodies cartoon "Elmer's Candid Camera," a redesigned Elmer Fudd sets out on a bucolic expedition to photograph wildlife, only to be harassed by Happy Rabbit (the Bugs Bunny prototype). Hijinks ensue until Elmer ends up in a lake with a copy of *How to Photograph Wildlife* on his head.

Original retail price: $9.95 USD.

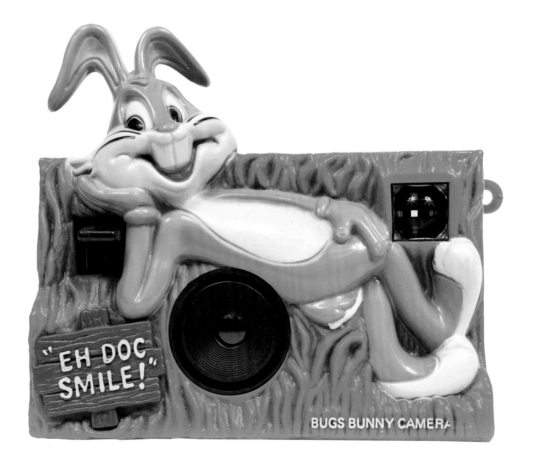

Camera: Bugs Bunny.

WALT DISNEY'S MICKEY MOUSE CAMERA
Manufactured in Hong Kong for Helm Toy Corp. Year: 1976. Film: 126. Flash: flash cubes.

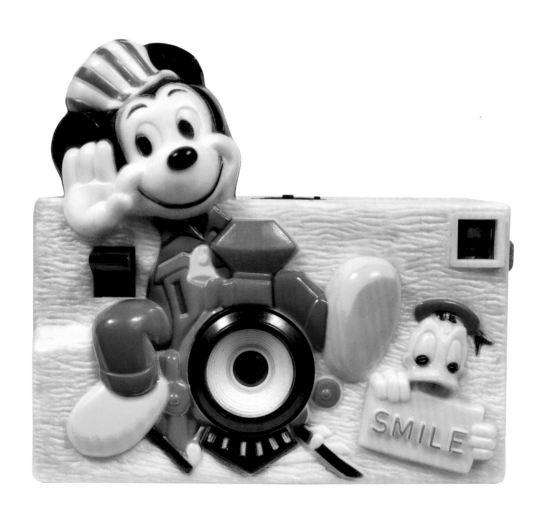

THE AMAZING SPIDERMAN CAMERA

Manufactured in Hong Kong for Vanity Fair. Year: 1978. Film 126.

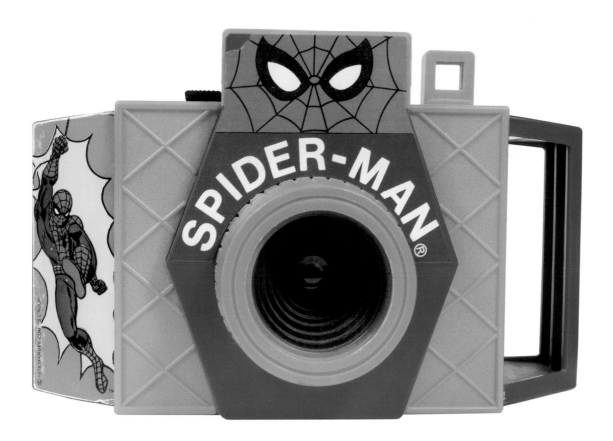

FRED FLINTSTONE CAMERA

Manufactured in Hong Kong. Year: 1975. Film: 126.

In "Flashgun Freddie," a 1962 episode from the third season of *The Flintstones*, Fred discovers a magazine called *Profits in Pictures for Amateurs* and decides that he and Barney will get rich as photographers. Fred convinces Barney to buy them a "Polarock" instant camera, which produces beak-pecked tablet images created by a bird inside the box, watching the scene from behind the faux lens. Needless to say, the two buddies don't get rich, and they learn that photography isn't all it's cracked up to be.

Original retail price: $5 USD.

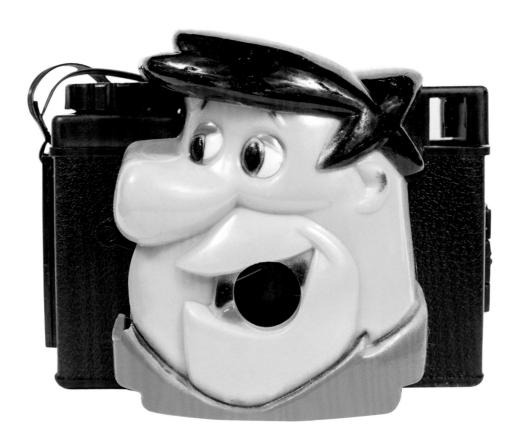

YOGI BEAR CAMERA

Manufactured in Hong Kong. Year: 1978. Film: 126.

The original blister card featured an illustration of Yogi sliding down a hill in a picnic basket, using his own branded camera.

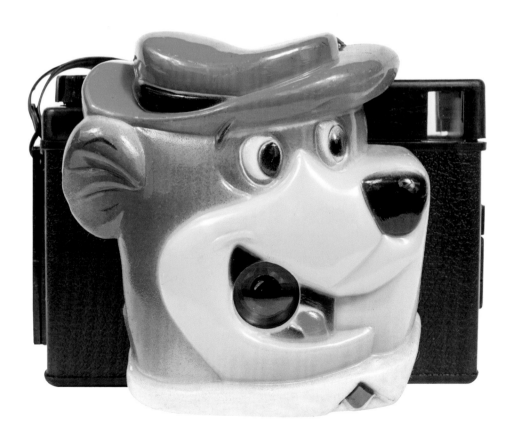

FUN FACE CAMERA

Manufactured in Hong Kong for Chadwick Miller Inc./Creative Creations Inc. Year: 1970s. Film: 126.

Generic novelty camera imported and distributed by many companies throughout the 1970s.

� Camera: Fun Face (girl).

CLOWN FACE CAMERA

Manufactured for Paradies Collection. Film: 110.

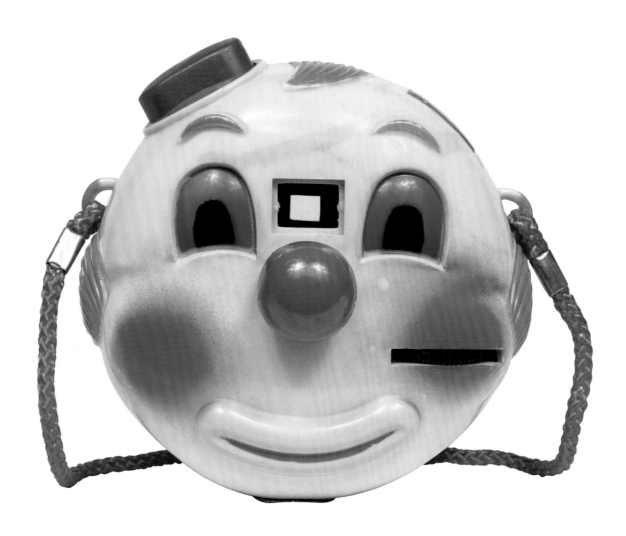

SANTA CLAUSE CAMERA

Manufactured in Taiwan. Film: 110.

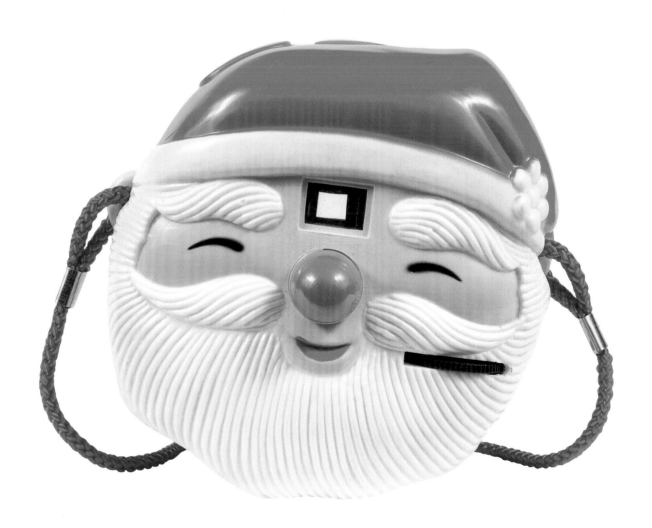

READY RANGER TELE-PHOTO CAMERA GUN

Manufactured in USA for Aurora. Year: 1974. Film: 126.

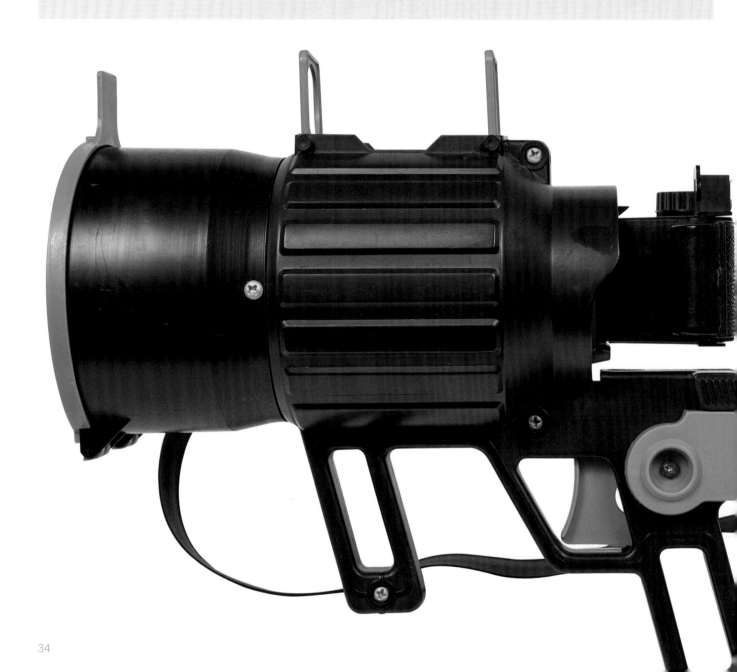

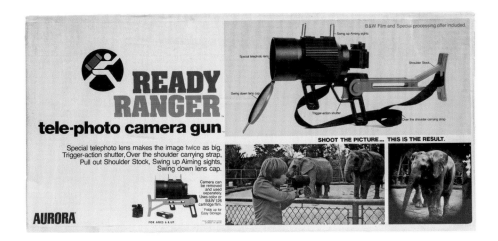

In an age of heightened security, cameras disguised as guns seem like relics of the past... and they pretty much are. This toy features a camera mounted to a large plastic "telephoto lens" with butt and pistol grip. The front of the box shows a little boy "shooting" an elephant.

Original retail price: $9.97 USD.

MASTERS OF THE UNIVERSE HE-MAN CAMERA

Manufactured in China for HG Toys. Year: 1985. Film: 110. Flash: x-type flash cubes.

On the packaging: "Take real pictures of all your heroes & friends!" A pink She-Ra Princess of Power version was released as well.

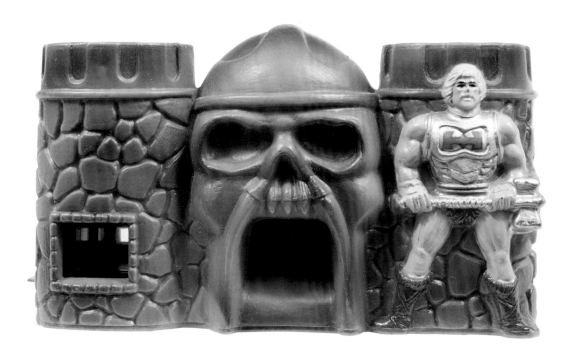

⬥ Camera: He-Man.

VOLTRON STAR SHOOTER CAMERA

Manufactured in Macau for Impulse Ltd. Year: 1985. Film: 110.

So many novelty cameras are really just about wrapping branding around a very simple camera, but the Voltron Star Shooter 110 is where form meets function. As a camera it looks like any number of toy cameras. Unfolded, however, the giant robot Voltron—made up of five robotic lions—stands tall as the character from the original animated television series *Voltron: Defender of the Universe*.

Camera: Voltron.

GOBOTS CAMERA

Manufactured in China for Playtime Products, Inc. Year: 1985. Film: 110. Flash: flipflash flash bulbs.

Nearly as popular, yet epically inferior to Hasbro's Transformers, the GoBots were released by Tonka in 1984 to incredible success.

The packaging proclaims: "A real camera just like Mom's and Dad's!"

Made of the same casing as the Cabbage Patch camera (page 43), which was touted as being "unbreakable."

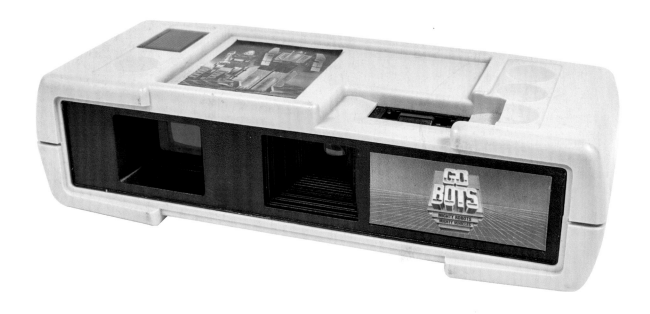

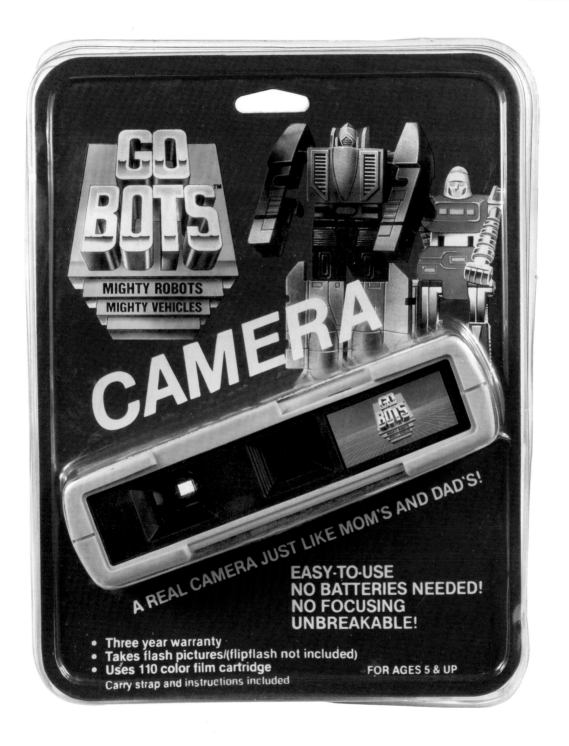

WHERE'S WALDO / CRAYOLA / NINTENDO / HOT WHEELS

Where's Waldo: Manufactured in China for Remco Toys. Year: 1990. Crayola: Manufactured in China for Concord Camera Corp. Year: 1995. Nintendo: Manufactured in China for Sakar. Year: 1997. Hot Wheels: Manufactured in China for Mattel. Year: 1991. Film: 110. Flash: built in.

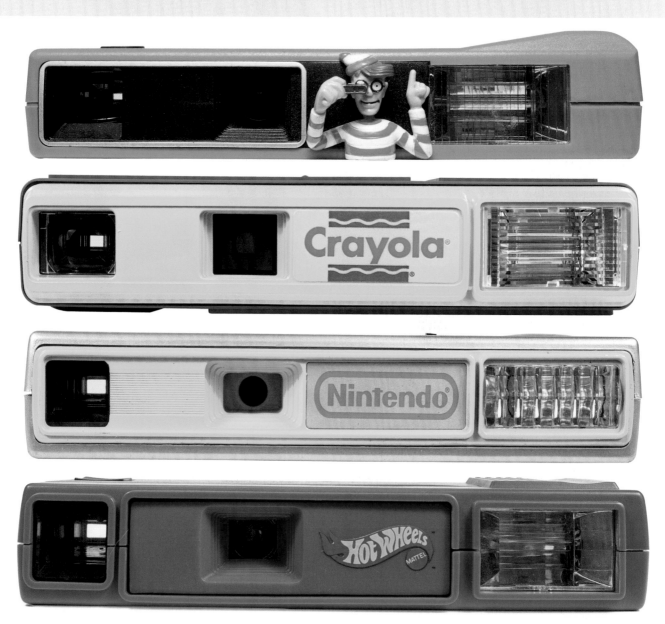

MICKEY-MATIC / KRAFT VELVEETA / CABBAGE PATCH KIDS

Mickey-Matic: Manufactured in Mexico for Eastern Kodak Co. Year: 1990. Kraft: Manufactured in China for Kraft Food Groups, Inc. Cabbage Patch Kids: Manufactured in China for Playtime Products, Inc. Year: 1985. Flash: flipflash flash bulbs. Film: 110.

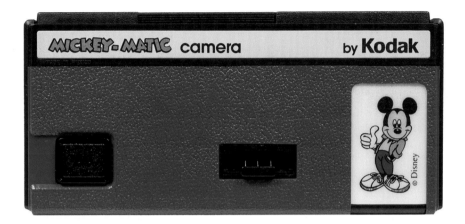

A mail-order promotion requiring three Kraft Velveeta Shells & Cheese box tops and $1 USD shipping and handling.

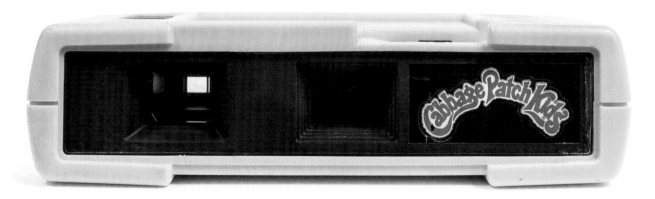

TEENAGE MUTANT NINJA TURTLES CAMERA

Manufactured in China for Remco Toys. Year: 1990. Film: 110. Flash: built in.

Available in five colors: orange, green, teal, yellow, and purple—which, unlike most TMNT products, had nothing to do with their four bandana colors. They all feature Raphael on the front of the camera, yet all claim to imprint Michaelangelo on the lower-right corner of every photo (both color and black and white imprint variants exist). A talking version was released as well, which spoke the recorded phrase "cowabunga, dude… for real" or "cowabunga dude… smile!" In the UK these were released under the name Teenage Mutant *Hero* Turtles, since—at the time—"ninja" was considered too dangerous a term for the Queen's children to comprehend.

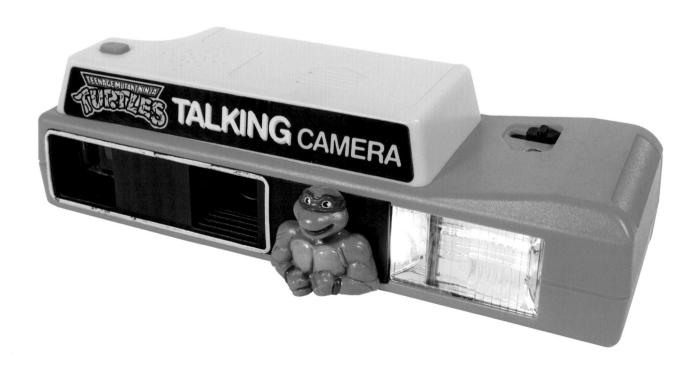

HULK HOGAN CAMERA

Manufactured in China for Remco Toys. Year: 1990. Film: 110. Flash: built in.

Imprints a color photo of the WWF's (World Wrestling Federation) flagship '80s character, Hulk Hogan, on the bottom right of every photo.

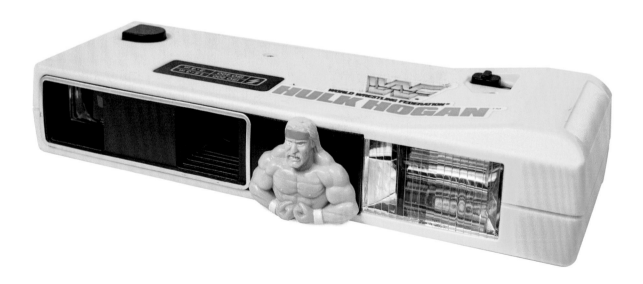

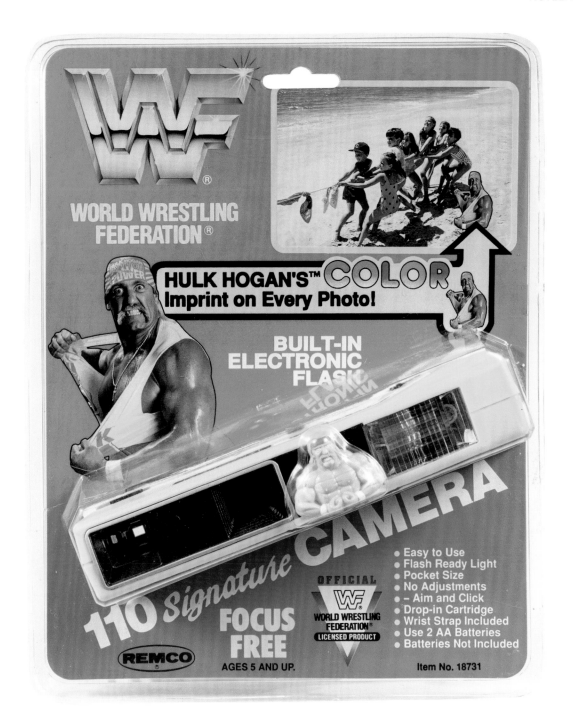

BARBIE JELLY CAMERA

Manufactured in China for Top Toys. Film: 135. Flash: built in.

The gimmick here is the slightly squishy rubber shell casing, which doubles as a protective case for the camera. It was released in four colors: blue, purple, green, and pink.

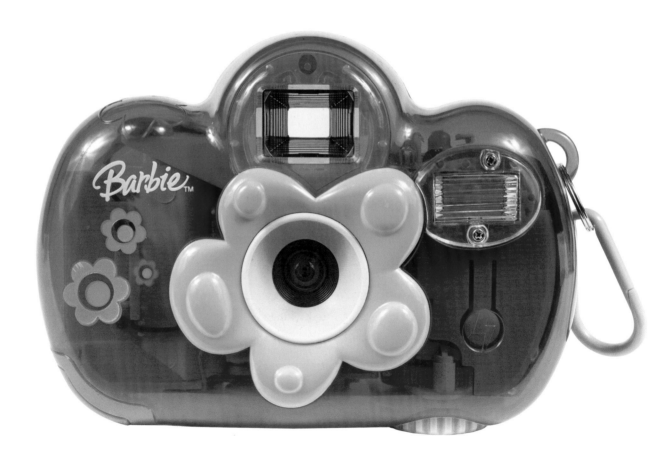

BARBIE OUTDOOR CAMERA

Manufactured in China for Tiffen Co., LLC. Year: 2000. Film: 110.

No built in flash, but it did come with a matching mini camera for your Barbie doll to hold.

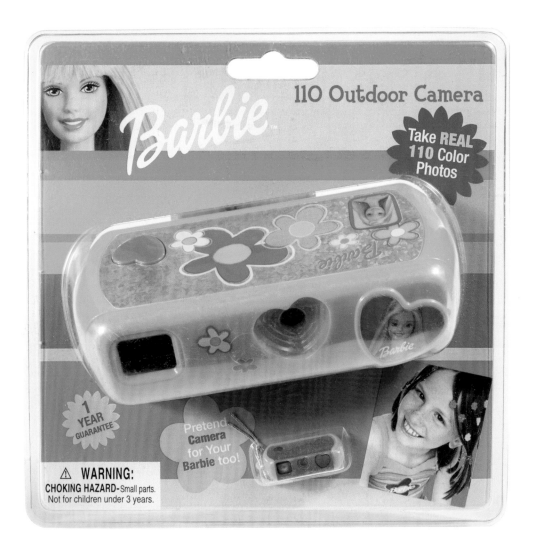

STAR WARS EPISODE I PICTURE PLUS IMAGE CAMERA

Manufactured in China for Tiger Electronics. Year: 1999. Film: 135. Flash: built in.

Styled like battle droid "electro-binoculars," this camera features an interchangeable slide of six different Star Wars characters to have superimposed onto the left side of each frame.

CRITTER CAMERA – VARIOUS

Film: 135.

POKÉMON CAMERA

Manufactured in China for Tiger Electronics. Year: 1999. Film: 135.

The copy on the packaging reads: "Capture the action on film of your favorite Pokémon adventure as Pikachu's immense electric charge puts the camera into focus and takes a picture! A special Pokémon border with all 150 Pokémon will magically appear on each photo."

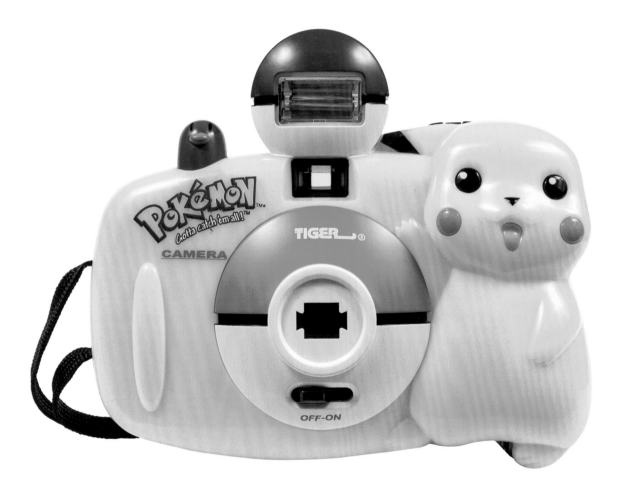

LOONEY TUNES TALKING FLASH CAMERA

Manufactured in China for Kalimar, Inc. Year: 1999. Film: 110. Flash: built in.

An "animation button" gives this camera light and sound effects. Phrases include: "Eh, what's up doc?"; "Sufferin' succotash!"; "You are despicable!"; "Oh, I taut I taw a puddy tat!"; as well as Taz's strange grunts. Also available in Tazmanian Devil and Sylvester & Tweety editions.

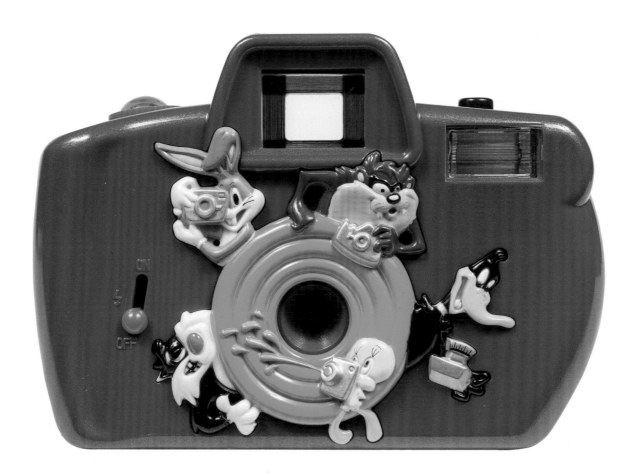

KAIJU BOOSKA CAMERA

Manufactured in China for Banpresto. Year: 1998. Film: 135.

Kaiju Booska was a popular Japanese live-action children's television program from the late 1960s, revived again in the '90s. "Monster" Booska was originally an iguana that was fed experimental food by his owner, turning him into a strange human-sized buck-toothed bear/giraffe hybrid creature. Booksa holds an orange filter for this camera, which gives images an otherworldly look.

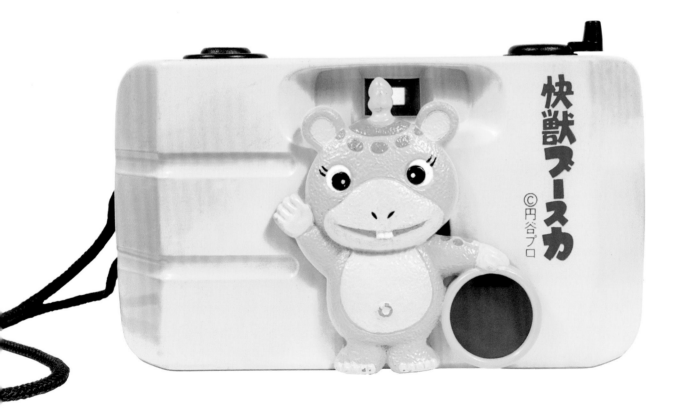

PEKO-CHAN CAMERA

Manufactured in China for Fujiya. Film: 135.

The little girl named Peko-chan is the pigtailed mascot
for the Japanese confectionary company Fujiya.

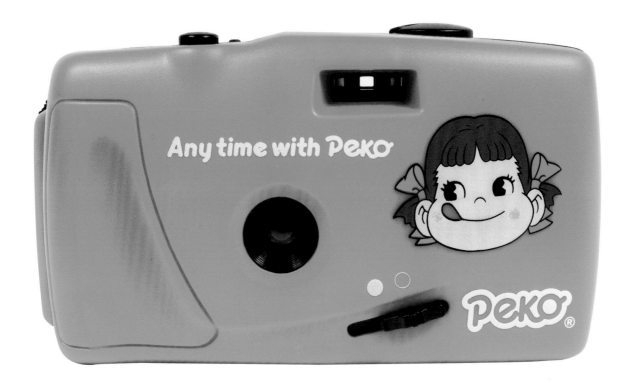

HELLO KITTY CAMERA

Manufactured in China for Sanrio. Year: 2000. Film: 135.

Sanrio's iconic feline is represented in the form of a 35mm camera. The entire front of her face slides up to expose the lens.

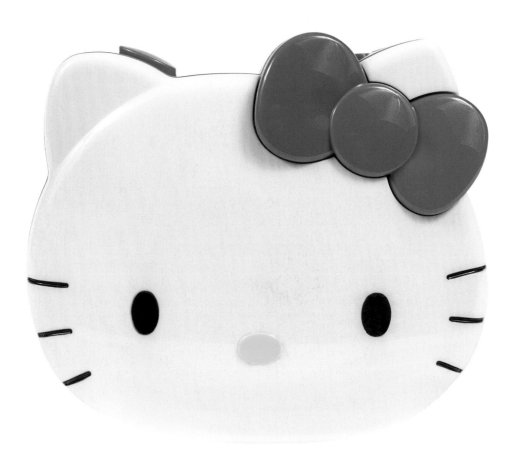

JIMMY NEUTRON ROCKET CAMERA

Manufactured in China for Viacom, Inc. Year: 2002. Film: 135.

Promotional item for the Nickelodeon animated series, released in conjunction with select Hilton Embassy Hotel Suites.

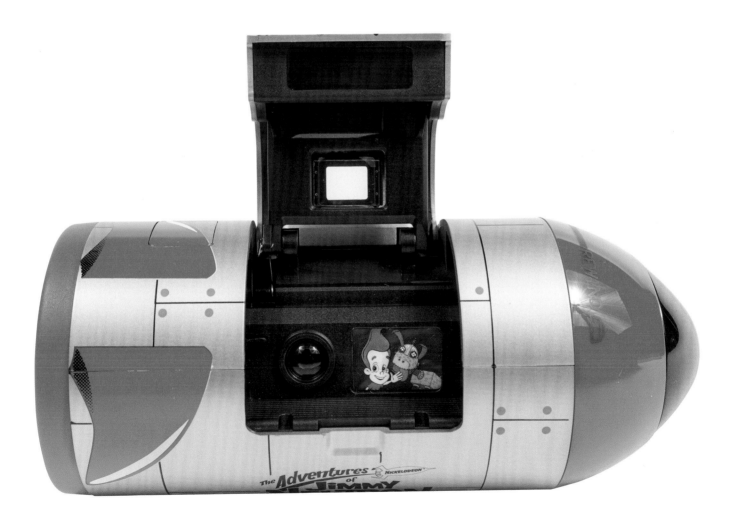

TAMAGOTCHI CAMERA

Manufactured in Japan for Bandai. Year: 1997. Film: 135. Flash: built in.

The handheld digital "pet" was released in Japan in 1996—the name is a portmanteau of the Japanese *tamago* (egg) and the English word "watch," or *uotchi*.

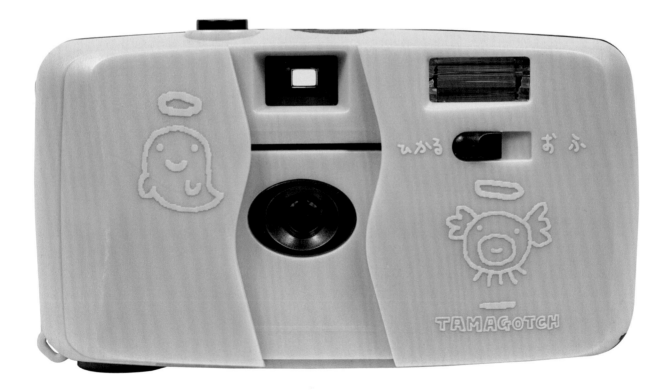

⊙ Comes with six interchangeable slides for adding Tamagotchi images onto your photos.

⊙ Camera: Tamagotchi.

DELUXE FRY CAM

Manufactured in China for Accoutrements. Year: 2000. Film: 135.

Not all novelty toy cameras are made to market a product or brand. Rather than promoting a specific American fast-food chain, this fry cam simply appeals to those who love French fries. While this particular toy camera has been taken out of circulation, the manufacturer has been in business for over twenty-five years, providing "the world with amazing products that provoke, challenge, and entertain."

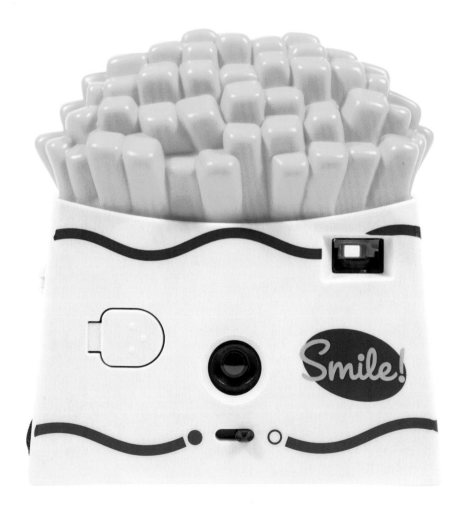

KFC CHICKEN CAMERA
Film: 135. Flash: hotshoe.

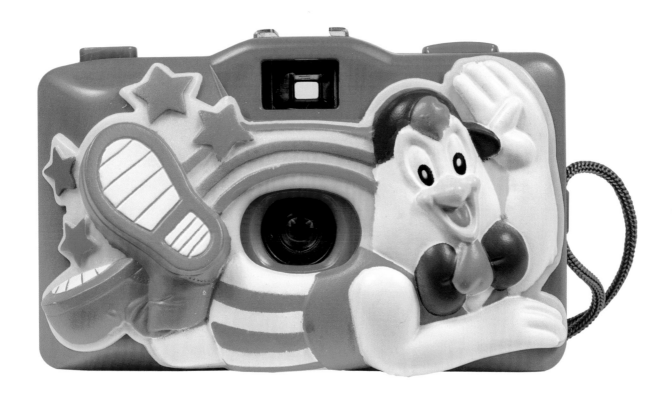

SPY KIDS / KELLOGG'S CORN FLAKES / DEWALT / ANSCO

Spy Kids: Manufactured in China for McDonald's. Year: 2001. Dewalt: Manufactured in China for Dupont.
Kellogg's: Manufactured in Taiwan for Kellogg's. Year: 1990. Ansco: Manufactured in Hong Kong for Haking. Year: 1980s. Film: 110.

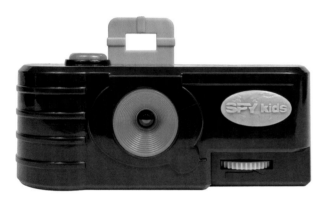

A Happy Meal toy and promotional item for the Robert Rodriguez kid-friendly action film, *Spy Kids*.

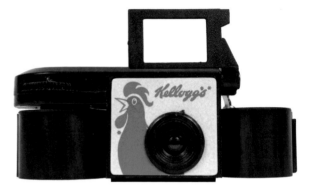

A mail order promotion requiring two Kellogg's cereal box tops and $4.95 USD shipping and handling.

Promotional micro camera for Dewalt Stren fishing line.

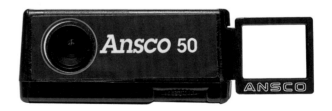

The grandfather to the Holga Micro-110 (page 116).

⬆ Camera: Ansco Mini.

CAN CAMERAS – VARIOUS MODELS

Year: 1970s–'90s. Film: 110 and 135.

The basic shape of the aluminum can was a natural concept for a disguised camera—the size fits the form, and it could be rebranded easily for different markets.

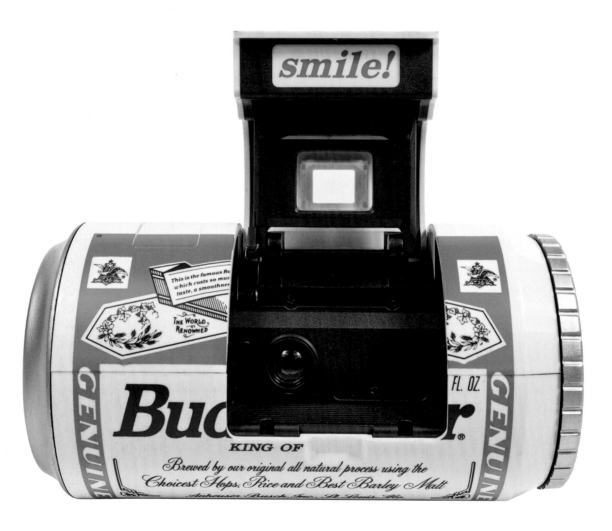

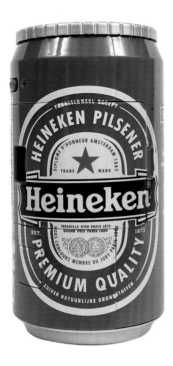

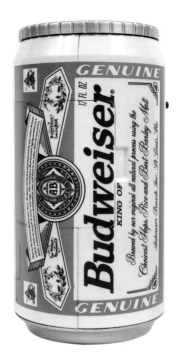

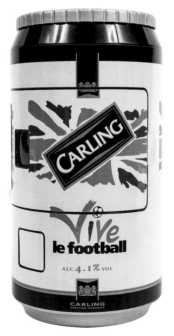

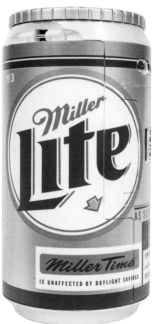

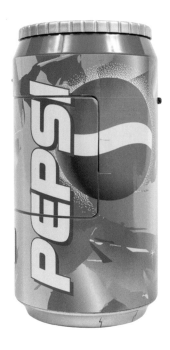

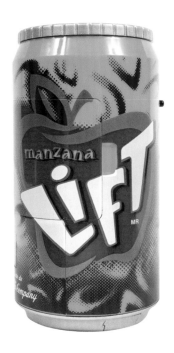

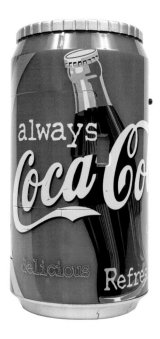

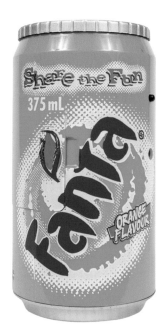

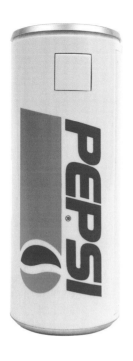

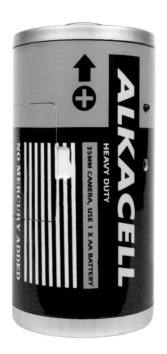

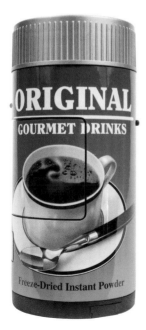

TIRE TYPE CAMERA
Year: 1981. Film: 110.

Also released branded as a Bridgestone Potenza tire.

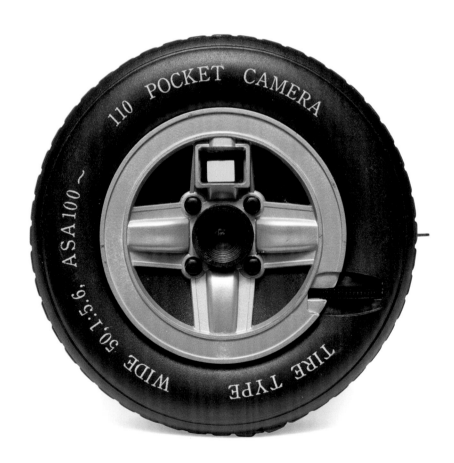

FRUTTOLO COW CAMERA

Manufactured in China for Nestlé Dairy Products. Year: 1997. Fixed focus. Film: 135. Flash: hotshoe.

Nestle released this camera in Italy under it's Fruttolo brand of yogurt; in Australia, the brand was called Mio. A mail order exclusive, this *mucca foto* (cow cam) was available for ten stickers (taken from yogurt packaging) along with postage and handling ($3 in Australia).

According to the original Australian sticker, the camera was limited to a production run of 4,900.

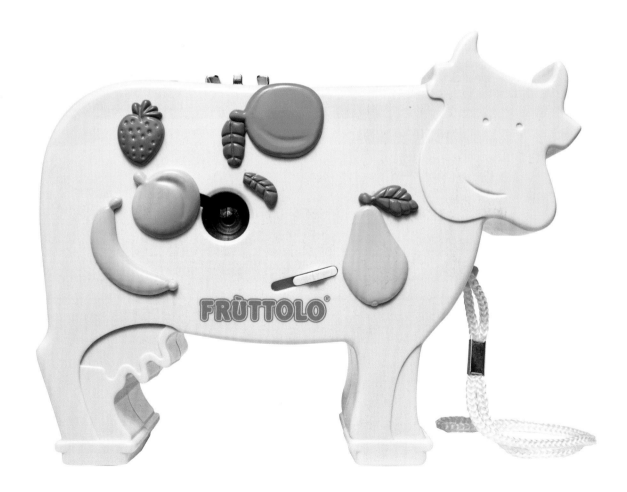

AIRPLANE CAMERA

Manufactured in China for Kineticolor. Film: 110.

Branded as a promotional item for United Airlines. The
nose of the plane opens to reveal the lens.

BEDLAM FOOTBALL CAMERA

Manufactured in China for Debenhams (London). Film: 135. Flash: built in.

There have been a few ball-shaped cameras: tennis, baseball, basketball, and this English-branded football camera.

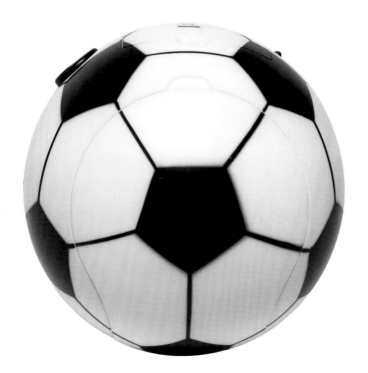

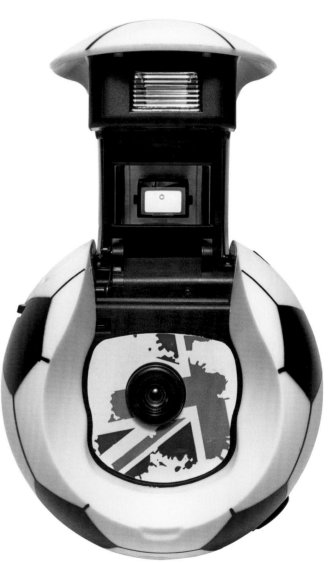

NICKELODEON PHOTO BLASTER

Manufactured in China for Long Hall Technologies/Nickelodeon Television Network. Year: 1997. Film: 135. Flash: built in.

This camera's ridiculous exterior might be marketed to kids, but the concept—four frames per shot—is aimed squarely at the adult consumer: "4 photos in one, save 75% on film and processing!" This "new invention" can be a fun challenge to use, since you need to match the lighting in each frame to achieve the best results.

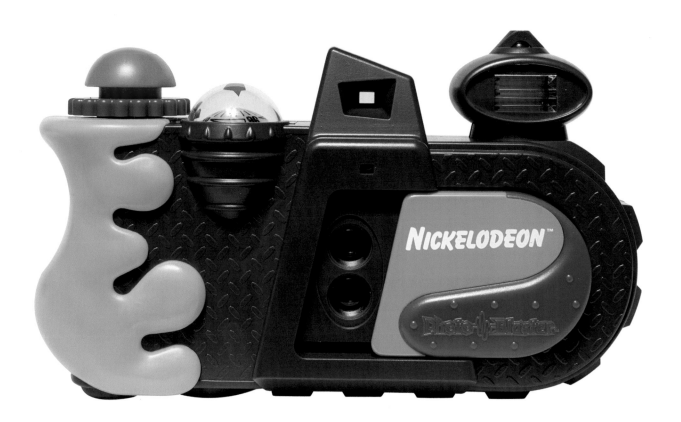

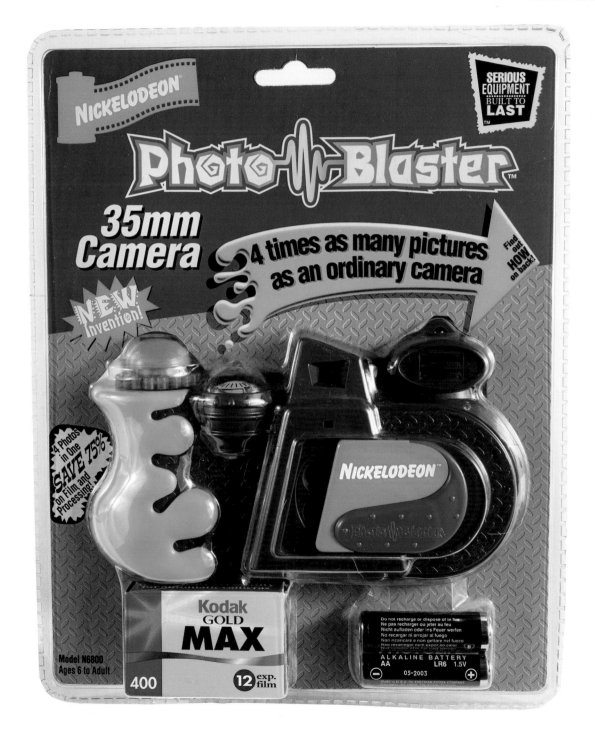

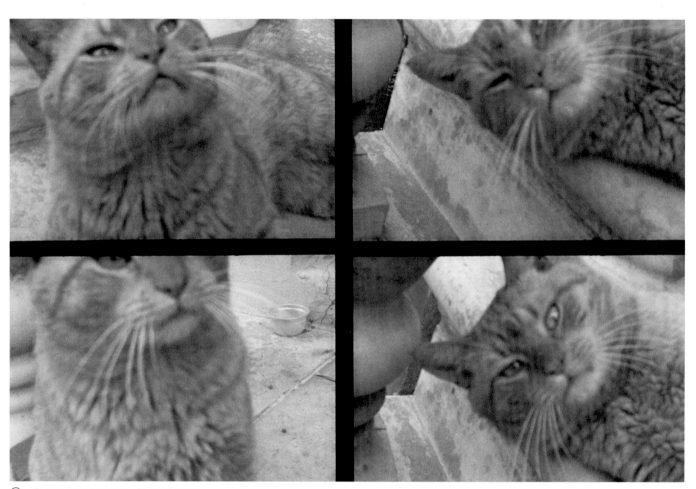

Camera: Nickelodeon Photo Blaster.

(▲) Camera: Nickelodeon Photo Blaster.

DRAGON BALL Z SPACESHIP CAMERA

Manufactured in China for MGA Entertainment. Year: 2000. Film: 135.

Made to resemble Frieza's spaceship from the popular Japanese anime/manga *Dragon Ball Z*, this camera uses four interchangeable slides to frame your photographs with images from the Japanese cartoon.

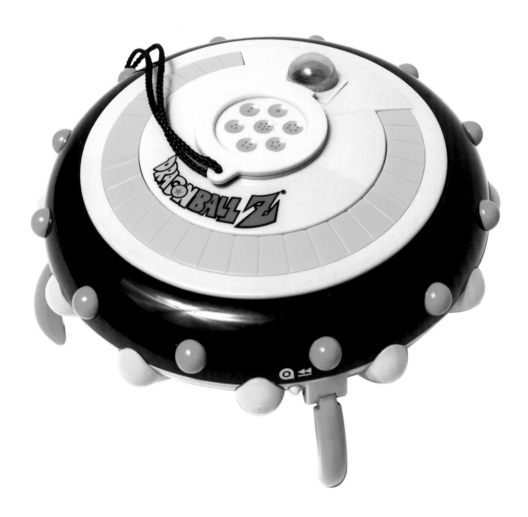

Comes with interchangeable slides to frame your image in *Dragon Ball Z* characters.

Camera: Dragon Ball Z Spaceship.

NATIONAL GEOGRAPHIC BINOCULAR CAMERA

Manufactured in China for Target. Year: 2005. Film: 135.

This is one of the more sensible collaborations in the book. While not everyone subscribes to *National Geographic*, almost everyone knows of the magazine's stature, thanks in part to the stunning photographs found on the cover and pages of every issue. Encouraging kids to get outside and photograph nature is a strategy that would inevitably lead to those kids using Kodak products and reading *National Geographic*.

Of course, not even the most intrepid explorers can escape the legalese of liability, hence the prudent warning on the packaging: "Caution! Viewing the sun may cause permanent eye damage. Do not view the sun with this product or even the naked eye."

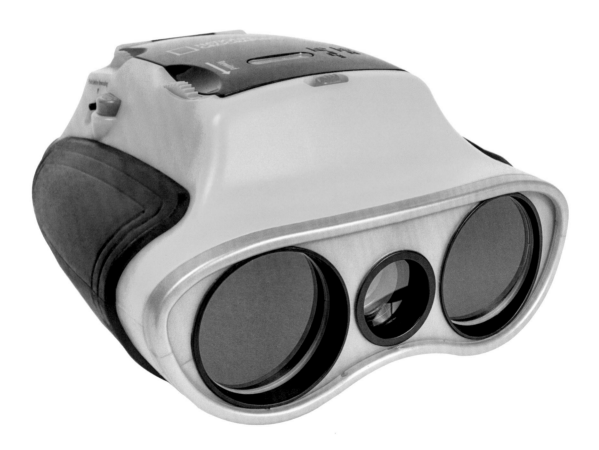

Camera: National Geographic Binocular.

REESE'S SPY TECH CAMERA

Manufactured in China for Tyco Toys. Year: 1992. Film: 110.

Packaged to do much more than promote a popular candy, the box trumpets it as "The Ultimate Miniaturized 110 Spy Camera!" that "Looks like a delicious candy bar, but it's not!" Disguised to look like two packs of peanut butter cups, the instruction manual features a detailed illustrated guide to the best practices for spying on others. One great tip: leave money on the ground to stall your subject and ensure a clear shot.

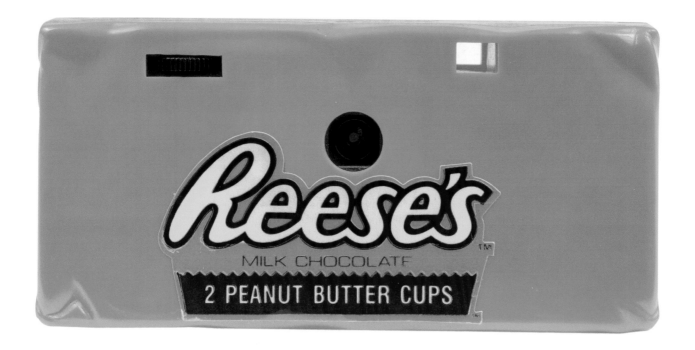

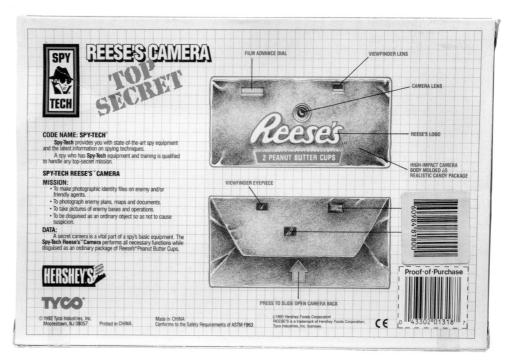

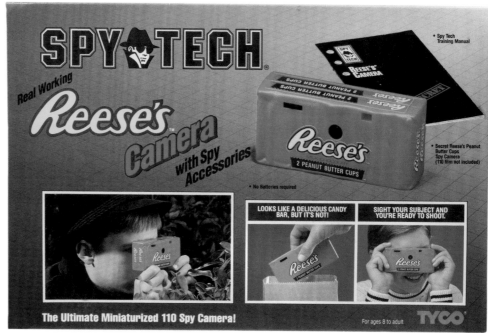

SPY GEAR SPY CAMERA, MINI CAMERA WITH SUNGLASSES

Manufactured in China for Wild Planet Toys. Year: 2002. Film: 110.

Long before digital technology and Google Glass, there was... this. A mini 110 mounted on the side of child-size sunglasses, with a wire-connected shutter release. Photographs are imprinted with a "Spy Cam" border, which—for some reason—resembles a timepiece.

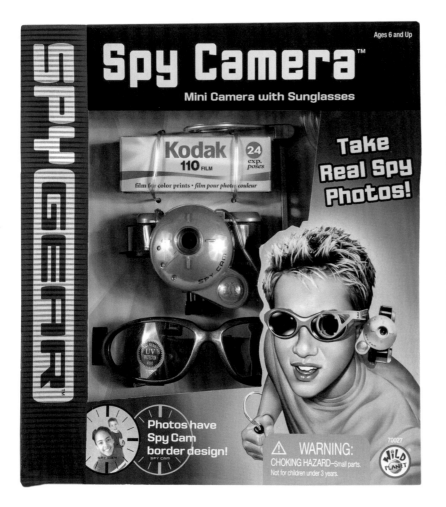

▲ Camera: Spy Gear.

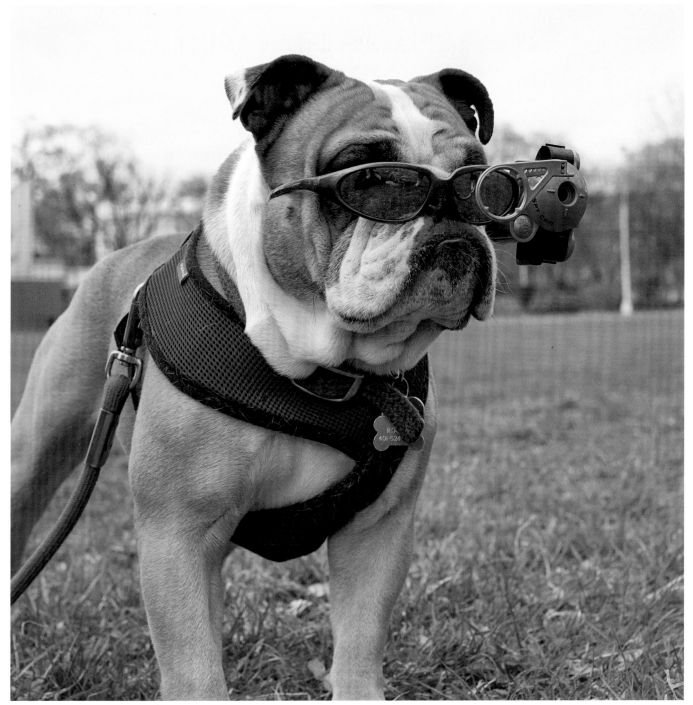

Rocky the dog, pretending to be a human spy.

WEBSTER'S DICTIONARY BOOK CAMERA

Manufactured in China for Shutter Chance. Year: 1970s. Film: 110.

An English dictionary in miniature form. Of note is the fact that the cover is printed on the back of the book, rather than on the front.

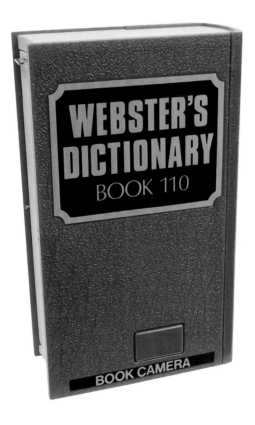

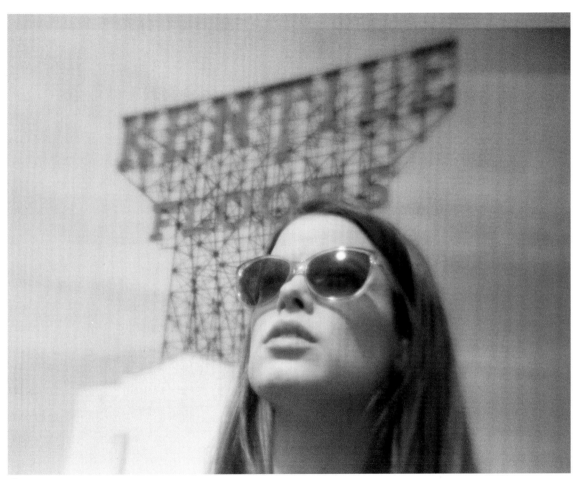

▲ Camera: Webster's Dictionary.

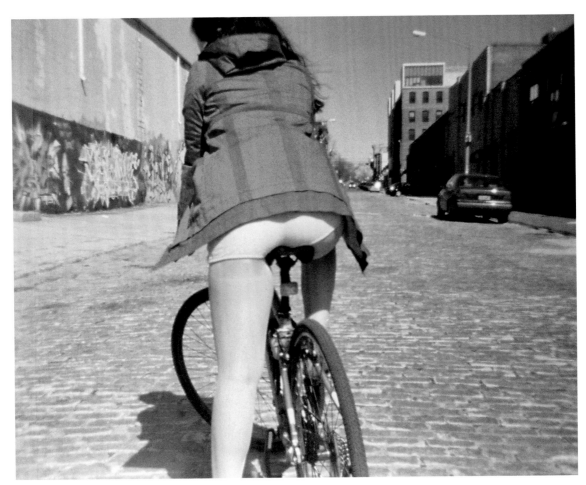

Camera: Webster's Dictionary.

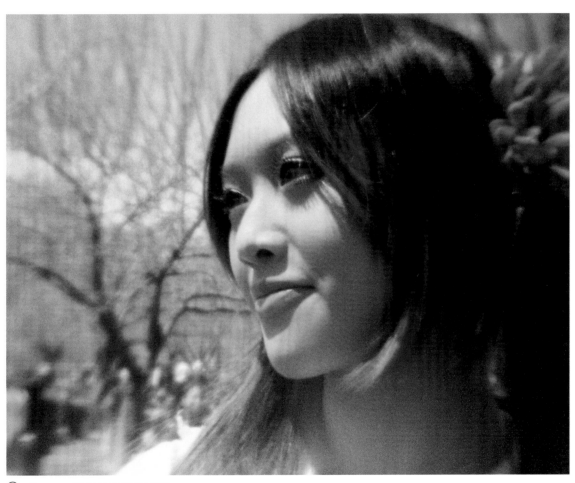

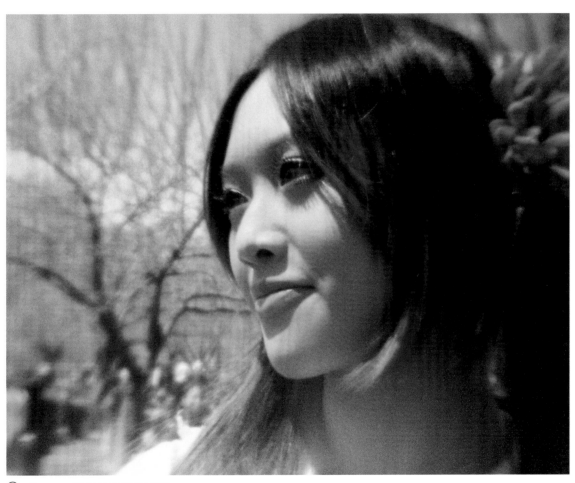 Camera: Webster's Dictionary.

TABASCO HOT SAUCE HOT SHOT

Manufactured in Taiwan for McIlhenny Company. Year: 1991. Film: 135.

INDIANA JONES WERLISA SAFARI CAMERA

Manufactured in Spain for Certex. Year: 1987. Film: 135. Flash: hotshoe.

The Werlisa was a Spanish-made 35mm camera initially manufactured by Certex of Barcelona. The Safari was a rebranding of an older existing camera, the Club Color B (1976), with a beige paint job and a few Indiana Jones stickers. Released in 1987 with a heavy youth-oriented marketing campaign, the Safari wasn't enough to keep Certex thriving through Spain's accession into the EU—they declared bankruptcy in 1988.

TIME MAGAZINE CAMERA

Kinetic Marketing Inc., Taiwan. Year: 1985. Film: 135. .

As part of a special television offer you received this camera along with 40% off the cover price for a year's subscription to *TIME* magazine.

Camera: TIME.

Camera: TIME.

⊙ Camera: TIME.

SPLIT-CAM IMAGE FUSION

Manufactured in China for Accoutrements. Year: 2004. Film: 135.

This camera takes two images per frame, splitting the image horizontally.

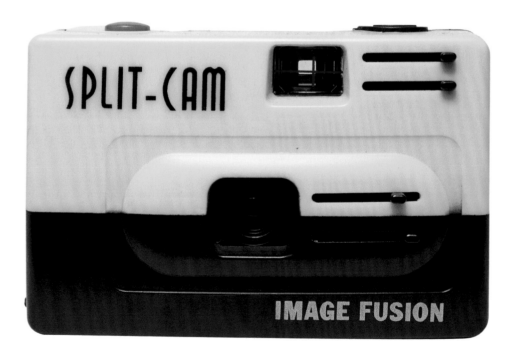

THE POP CAM

Manufactured in China for Accoutrements. Year: 2003. Film: 135.

Another quad-cam, this one with color filters meant to mimic an Andy Warhol or Roy Lichtenstein—should you believe the sales copy.

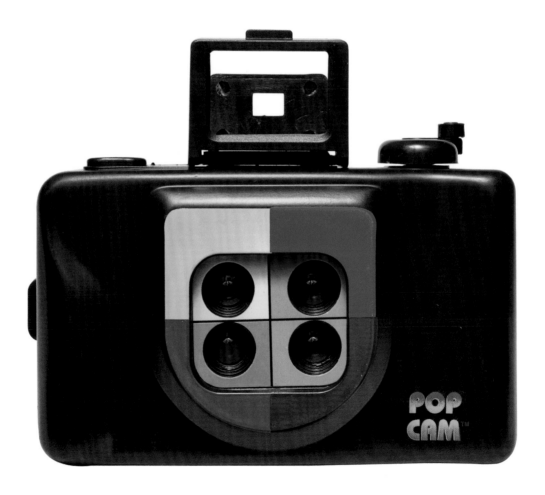

DIANA, HOLGA & THE PLASTIC CAMERA BOOM

DIANA

Manufactured in Hong Kong by Great Wall Plastic Co. Year: 1960s-'70s.

A fall 1977 article in *Popular Photography* magazine championed the Diana as a "99-cent marvel." Since its creation in the '60s, the Diana has only grown in cult popularity—from the early '70s work of photographer Nancy Rexroth to the modern re-release of the camera by Lomography. This is the camera that birthed the toy camera movement.

Focus	zone
Lens	75mm
Aperture	f/11, f/13, f/19
Shutter speeds	1/100, bulb
Focal distance	4-6ft, 6-12ft, 12ft to infinity
Film	120

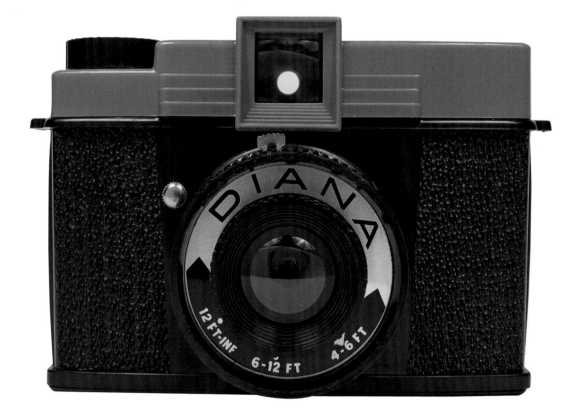

⏶ Camera: Diana.

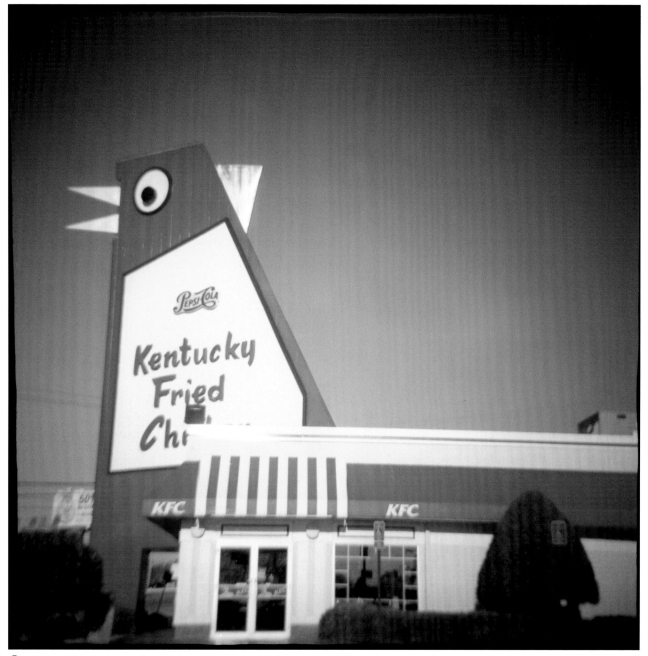

Camera: Diana.

Camera: Diana.

NORTHAMERICAN CHAMPION CAMERA

Manufactured in Hong Kong. Year: 1970s.

A Diana clone with a truly unique name, clearly made for the Western market.

Focus	zone
Lens	75mm
Aperture	f/11, f/13, f/19
Shutter speeds	1/100, bulb
Focal distance	4-6ft, 6-12ft, 12ft to infinity
Film	120

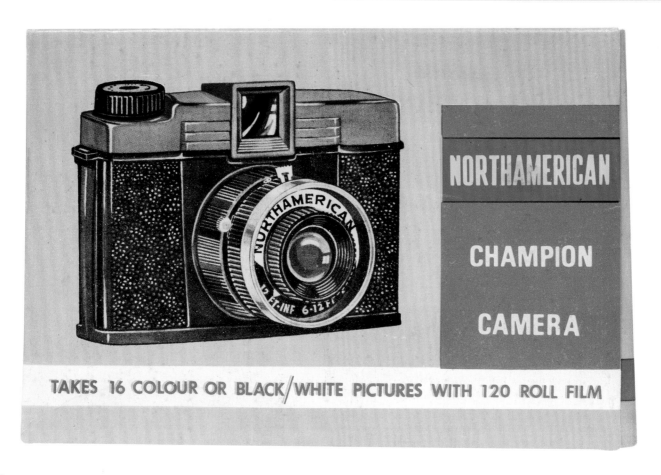

TAKES 16 COLOUR OR BLACK/WHITE PICTURES WITH 120 ROLL FILM

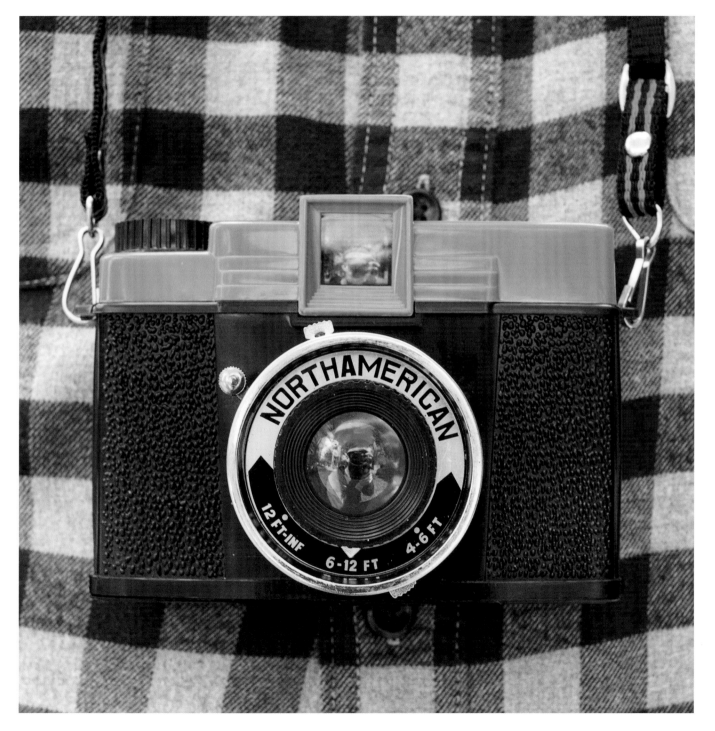

▲ Camera: NorthAmerican Champion.

Camera: NorthAmerican Champion.

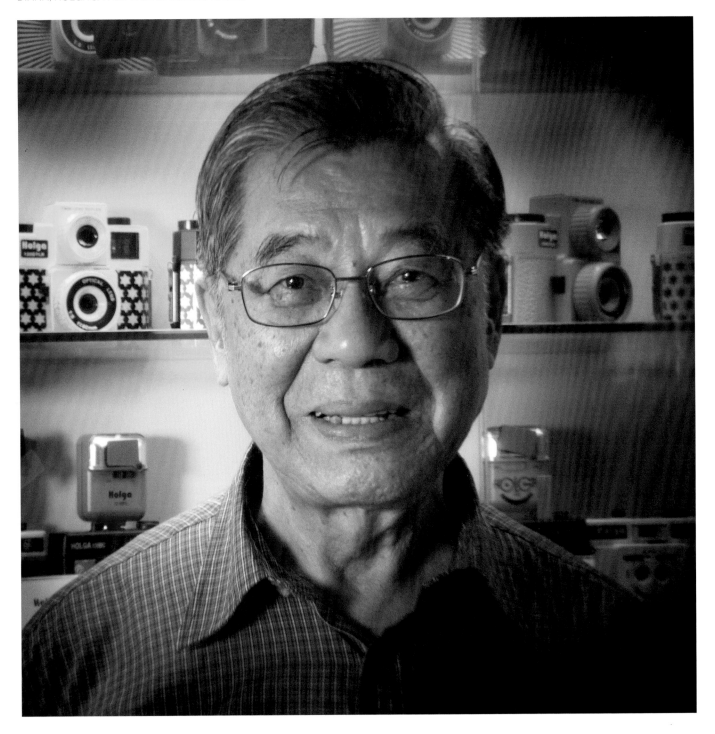

HOLGA: AN UNLIKELY SUCCESS
INTERVIEW WITH MR. T.M. LEE, CREATOR OF HOLGA

In the late 1960s, T.M. Lee worked in Hong Kong as the factory manager for the Japanese-owned Yachica camera company. Leaving Yachica after only a few years, Lee teamed with his brothers to start a new business venture: Universal Electronics Industries (UEI). They started out producing capacitors for radios but found initial success in making flash units for cameras. But with the '70s came the built-in electronic flash, and business all but grinded to a halt. In order to survive, they had to look to other products, and it was here that the Holga was born.

The original Holga camera—the Holga 120S—was released in China in 1981. Developed by Lee, his intention was to produce an affordable camera for the Chinese market—with 120 being the most widely used film. Low budget and low quality, the camera was susceptible to light leaks, vignetting, lens blurs, and other unexpected results. Little did Mr. Lee know that, years later, his idiosyncratic medium-format plastic camera would spark a photography movement in the West.

To this day, no one quite knows what to call Lee. Is he the founder of Holga, or its father? Ultimately the title doesn't matter, since Lee remains the driving force of Holga. He is in the office every day and continues to design and develop new products.

Your first foray into the production of camera components started with UEI. What drew you to the medium?

UEI was set up in 1969 during the heyday of the manufacturing sector in Hong Kong. We first produced components for radios, which were in high demand, such as electronic capacitors. But there were many other companies producing similar products so the competition prompted me to look for a new product to bring to the market. External flash units for cameras soon caught my attention because at that time there were only a few factories that produced them. I sought out technical expertise from Japan and our first flash unit was designed there. The flash bulb business proved to be successful so I started to design and develop the second model on my own. It was quite a surprise when the flash bulb that I designed received local and international attention. It even received numerous awards, including the 1972 FHKI Award for Good Design, in the electronics category. The news spread, and it reached Agfa Camera in Germany. Agfa approached us to manufacture flash bulbs for their products. Our business was blooming for about ten years. But then it drastically dropped until Konica invented the world's first camera with a built-in flash. In order to survive, I came up with the Holga cameras.

You developed the Holga to fulfill the early '80s demand for cameras in China. What were the cultural factors that made Chinese people want cameras? Were other camera companies advertising in China? Were Chinese consumers seeing the popularity of photography in other countries?

During the early '80s, there were some renowned domestic brands in China, such as Seagull and Phoenix. There were also some other camera manufacturers owned by the Chinese government and these state-owned manufacturers received technical support from the Soviet Union, but they mainly produced expensive, high-tech cameras, such as the Single Lens Reflex Camera, which was too expensive for the mass market.

At this time in China, photography was considered an unaffordable luxury. Most people wanted to capture family moments and special occasions but it was very difficult for them. I seized the opportunity of the economic open door policy by introducing an affordable 120 medium-format camera. In the meantime, the open door policy permitted foreign brands into the Chinese market. Unfortunately, people preferred foreign brands over domestic brands, so we couldn't capture market share in the way we'd planned.

Are you a photographer as well as a camera maker? How much has using other cameras, both analog and digital, informed new Holga models? What were some of the preexisting cameras that helped inspire the original Holgas?

I am not a photographer. I designed and developed cameras with the aim of catering to the market. I have always tried to be adaptive to the market. It turns out that the market helped inspire me. Holga itself is quite original. It was the world's first medium format camera with a built in flash.

It's well documented that at first, sales of Holga cameras were disappointing. But when artists and professional photographers started appreciating the aesthetic visual qualities of the images made by Holgas, the popularity skyrocketed. Did this development surprise you?

Yes the development surprised me and totally exceeded my expectations.

Were you happy with how the initial Holga models performed? Did you like how the photographs printed?

To be honest, I was not satisfied with the "imperfection," such as vignetting and light-leak effects. I tried to alter the design of the cameras in order to avoid these "imperfections." But later I realized they were becoming Holga's signature characteristics.

Today, Holgas come in a wide range of styles. What inspired you to make so many diferent types of Holgas available to consumers?

I am open to feedback and suggestions. I suppose being adaptive and flexible in terms of what the market demands made me invent different types of Holgas.

The Holga Inspire initiative supports photography from all over the world. How has the direct relationship with artists been beneficial to the brand? What was the impetus for the project?

Photojournalist David Burnett's award-winning photo of Al Gore on the campaign trail in 2000 caught our attention. That was the moment we realized that serious artists and famous photographers are our loyal fans. We thought their Holga work could truly inspire others. It is such a strong statement that an incredible artwork can be made by such a simple and minimalistic camera like

the Holga. We are thankful for all the artists who have been longtime supporters of Holga. We want to encourage everyone to use the Holga as the tool for creative and artistic expression.

(translated by Christine So of Holga Inspire)

▲ Camera: Holga 120CFN.

HOLGA 120CFN

Focus	zone
Lens	60mm
Aperture	f/8, f/11
Shutter speeds	1/100, bulb
Focal distance	1m, 2m, 6m, 10m to infinity
Flash	built in with four filters
Film	120

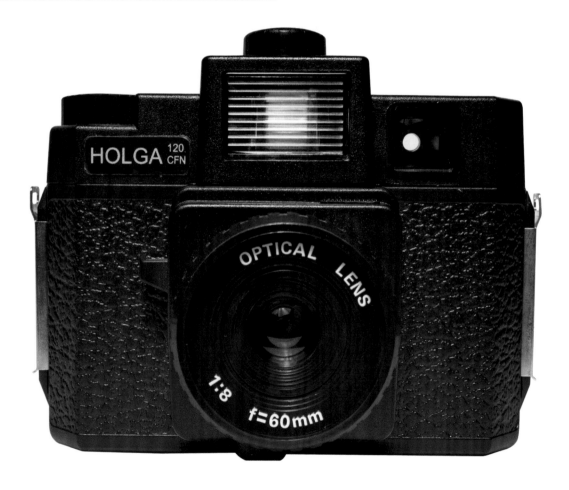

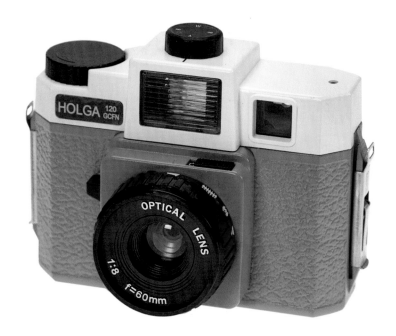

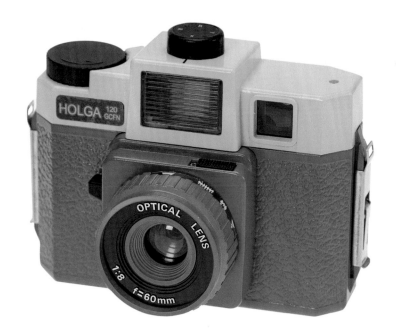

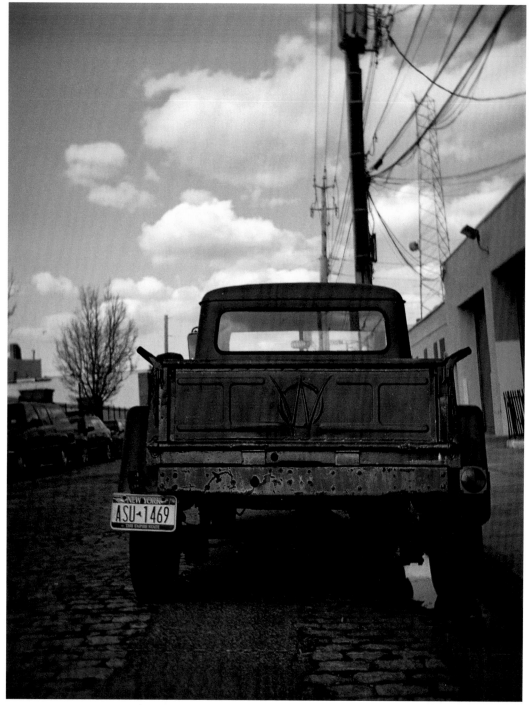

Camera: Holga 120CFN.

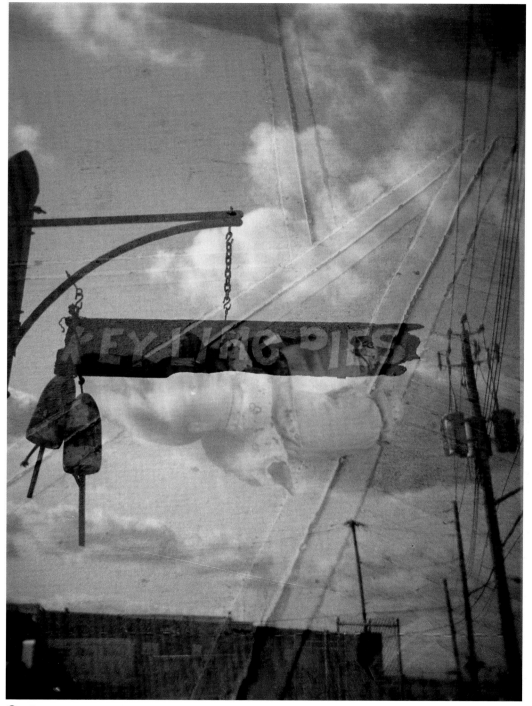

⊕ Camera: Holga 120CFN.

HOLGA 135BC

Focus	zone
Lens	47mm
Aperture	f/8, f/11
Shutter speeds	1/100, bulb
Focal distance	1m, 2m, 6m, 10m to infinity
Flash	hotshoe
Film	135

The "BC" stands for "black corners," as this Holga contains an internal mask for soft vignetting.

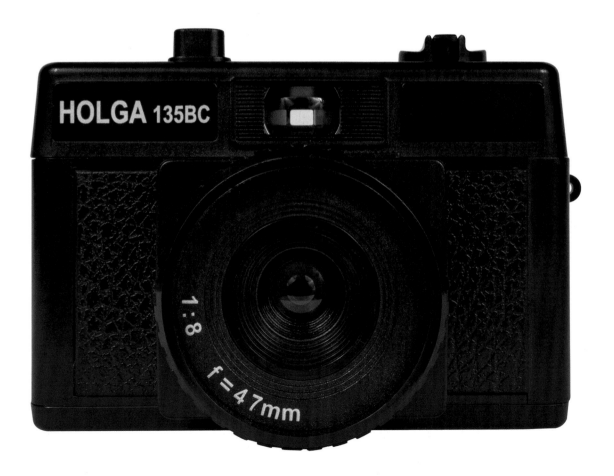

HOLGA 135TIM

Focus	fixed
Lens	29mm (x2)
Aperture	f/8, f/11, f/22
Shutter speeds	1/100, bulb
Focal distance	1m to infinity
Flash	hotshoe
Film	135

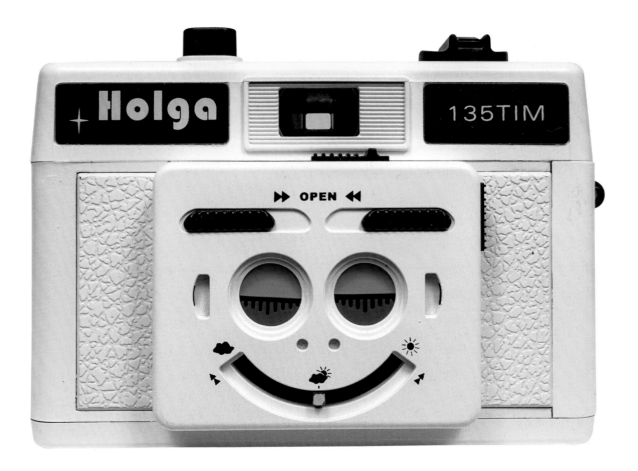

HOLGA MICRO-110

Focus	fixed
Lens	25mm
Aperture	f/8
Shutter speeds	1/125
Film	110

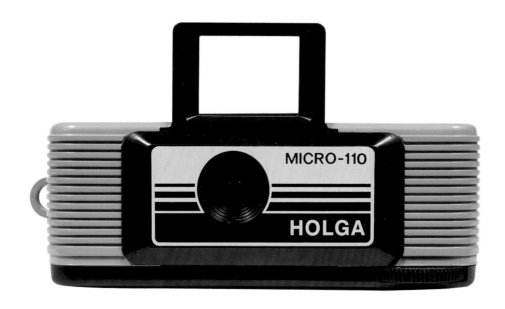

⏺ Camera: Holga Micro-110.

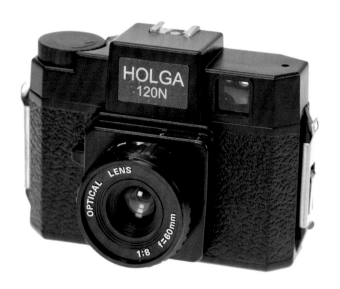

HOLGA 120N

Focus	zone
Lens	60mm
Aperture	f/8, f/11
Shutter speeds	1/100, bulb
Focal distance	1m, 2m, 6m, 10m to infinity
Flash	hotshoe
Film	120

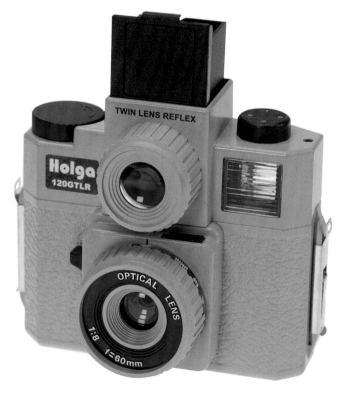

HOLGA 120GTLR

Focus	zone
Lens	60mm (glass)
Aperture	f/8, f/11
Shutter speeds	1/100
Focal distance	1m, 2m, 6m, 10m to infinity
Flash	built in color splash
Film	120

HOLGA 120PC3D

Pinhole	0.30mm (x2)
Aperture	f/135
Shutter speeds	bulb
Film	120

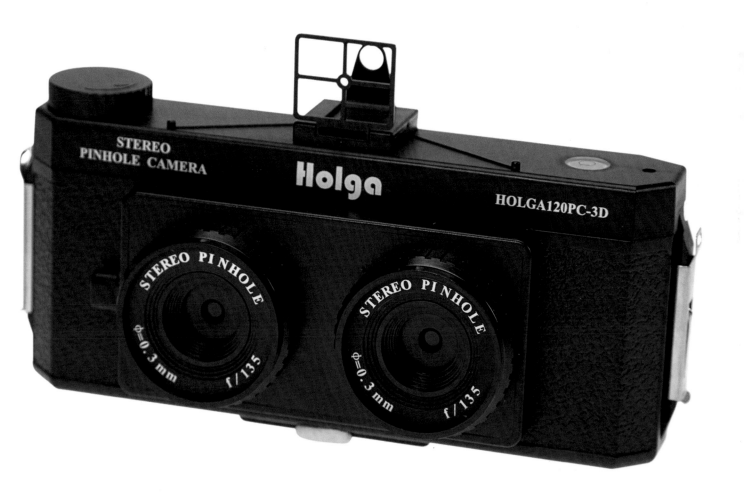

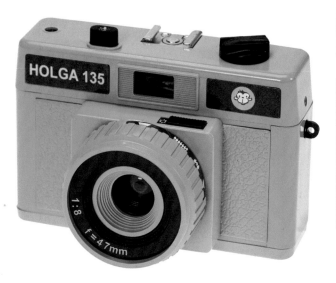

HOLGA 135

Focus	zone
Lens	47mm
Aperture	f/8, f/11
Shutter speeds	1/100, bulb
Focal distance	1m, 2m, 6m, 10m to infinity
Flash	hotshoe
Film	135

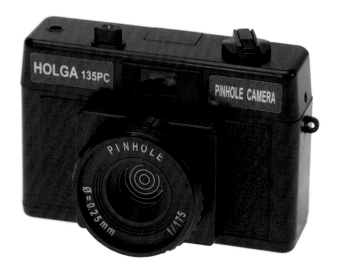

HOLGA 135PC

Pinhole	0.25mm (x2)
Aperture	f/172
Shutter speeds	bulb
Film	135

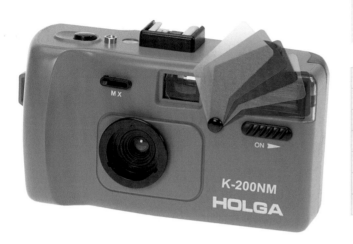

HOLGA K200NM

Focus	fixed
Lens	FEL-135K fisheye
Aperture	f/8
Shutter speeds	1/100, bulb
Focal distance	1m, 2m, 6m, 10m to infinity
Flash	built in with color filters
Film	135

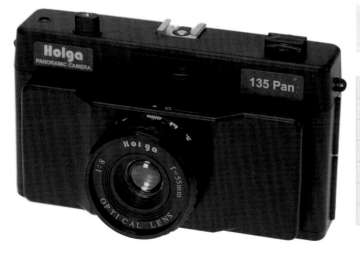

HOLGA 135PAN

Focus	zone
Lens	55mm
Aperture	f/8, f/11
Shutter speeds	1/100
Focal distance	1m, 2m, 6m, 10m to infinity
Flash	hotshoe
Film	135

LOMOGRAPHY & THE ANALOG MOVEMENT

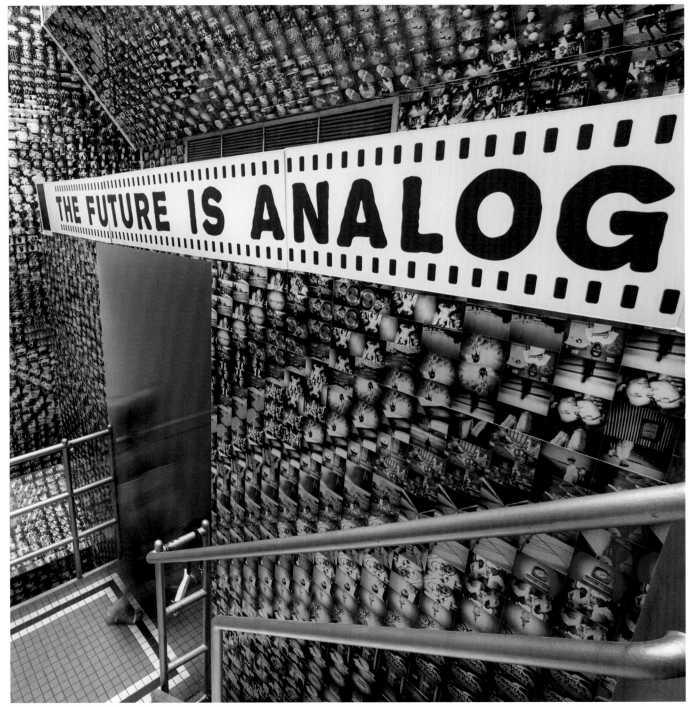

The New York City Lomography store.

LOMO: FILM'S RESPLENDENT FUTURE
INTERVIEW WITH LOMOGRAPHY

Lomography is a philosophy and a brand that took shape in Vienna, Austria, in the early 1990s. Inspired by inexpensive Russian cameras that were readily available throughout Eastern Europe (and perhaps propelled by the ripple effects caused by the fall of the Berlin Wall) Lomography quickly became an international movement, replete with a manifesto penned by Lomography Society International (LSI): the Ten Golden Rules. A dedication to creativity and freedom of expression resulted in a demand for cameras and accessories to be developed around the LSI ethos. Today, Lomography remains true to the principles of its founders while also producing an astounding array of toy cameras designed to bring out the Lomographer in everyone.

In keeping with the company's collective spirit, this interview was permitted on the condition that it would be credited to "Lomography."

When Viennese students discovered the LOMO LC-A in Prague, what exactly drew them to it? They had no idea that the photographs would be so aesthetically unique, so what was it about the physical object that tempted them to buy the camera?

Matthias Fiegl was helping the Austrian photographer Heinz Cibulka, one of the most influential photographers in Austria, to set up an exhibition in Prague. Heinz actually told Matthias about the LC-A, so he bought one and brought it back to Vienna. Back home, everybody tested the new camera and this new approach to photography, and the way of presenting it, came out; this was the start of Lomography.

It's remarkable that a camera produced for the Soviet military served as the impetus for Lomography. Did the cameras get much military use before being made available in the Russian market in 1984?

Actually the camera was never made for military purposes—this might be a misunderstanding. At this time in Russia, optical products were produced within factories that also made military products. The ministry of defense and industry was responsible for these factories. On one of his visits to Japan, the minister saw the Cosina CX-2, brought it back to Russia and had Lomo PLC develop a copy of that camera. This was the Lomo Compact Automat (LC-A). This camera was intended to be a camera that everyone uses. And if you talk to someone from Eastern European countries, they will tell you that they grew up with the Lomo LC-A.

Are there any infamous stories regarding LSI members smuggling in cameras from various Soviet bloc countries?

In the early days, we were not organized through a legal structure; we were just a group of students organizing

events and exhibitions. But more and more people wanted to have a LC-A camera. The only way to get them in the beginning was to find old stock in Eastern European countries, which we then brought by train to Vienna, a three-day trip. The backpacks got larger and larger and at one point the customs officers knew about us. So we started to have many cameras confiscated at the borders, as it was difficult to explain why we needed old Russian cameras. By going international and creating such demand, we were forced to find a working solution, so we then contacted Lomo PLC.

What factors played into the LSI going from being a sort of informal student group to a city-sanctioned organization? In the early '90s was it common for the Vienna City Council to provide headquarters for such cultural initiatives? How did LSI become so popular in Vienna?

In the early '90s, Vienna changed dramatically as it suddenly, through the opening of communist countries, became a new center of Europe. And that influenced art a lot— there was so much going on in all different fields of art. It was easy to find places to show exhibitions, although many of them were kind of underground, like garages and small private lounges.

As young students with lots of time to party and shoot with the LC-A to create a new way of understanding photography, we developed the idea of a Lomowall and communicated the Ten Golden Rules to present Lomography. These exhibitions and events attracted many creative people and press. This is how the idea of Lomography spread. We launched our first website in 1996 and had exhibitions all over the world—and so Lomography became international. In places like Berlin, Tokyo, London, Paris, and New York we were invited for exhibition projects at a very early stage after the start of Lomography.

Who are some other artists and figures who served as an inspiration for the movement?

Just like today, we understand art and creativity to be an essential part of all our personal lives, but also as a base for any kind of decision for Lomography. Especially in the early days, being young students we were very influenced by many artists from many different fields, not only photography. Our close Russian friends who helped us to understand the Russian culture: painters, writers and architects. And other well-known artists

THE TEN GOLDEN RULES OF LOMOGRAPHY

1. Take your camera everywhere you go.
2. Use it any time—day and night.
3. Lomography is not an interference in your life, but a part of it.
4. Try the shot from the hip.
5. Approach the objects of your Lomographic desire as close as possible.
6. Don't think.
7. Be fast.
8. You don't have to know beforehand what you captured on film.
9. Afterwards either.
10. Don't worry about the rules.

We understand Lomography as an art movement for enhancing creative and experimental photography, as well as a brand and company with our own product developments. This core value offers us huge potential, but it is also a big responsibility to remain true to what Lomography stands for. There are millions of Lomography community members in the world whom we have to respect and honor with everything we produce and communicate.

All Lomography cameras represent something special for photography and give their users the possibility to play around, express, and learn. We have cameras that feature color experiments (Colorsplash, different flashes); movie photography (Action Sampler and Lomokino); 120mm photography (Diana, Lubitel); DIY themes (Sardina and Konstruktor); and other techniques.

Some of our cameras are so special and complicated in their construction that you could not produce them in other factories, as most of today's manufacturers do not have the knowledge anymore. This is what we experienced when we set up a new LC-A production.

In 2012 the BBC published an article asking the question: "Did the Lomo camera save film photography?" How do you feel about this question in general? Why do you think Lomography is so popular? Is it the unpredictable nature of the photographs that excites people? Is it the brand's emphasis on photography being something that should be fun and not too serious or over thought?

It's definitely a mixture of all of the above. The most important thing is Lomography is the only brand nowadays that develops and produces film cameras, and has done so consistently for more than twenty years. We also develop and produce our own film products. And we

and photographers, who we met and who worked with the LC-A and influenced Lomography in the early days: Alexander Djikia, Andrej Turkin, Dmitri Vrubel, Nina Kercelli, Heinz Cibulka, David Byrne, Araki, Yasumasa Yonehara, Wolf D. Prix, Matthew Barney, and many more. But right from the start Lomography also approached people who were not necessarily part of the art scene. People of different ages and from different cultures; everybody could be part of the Lomography communication, exhibitions, and events.

Can you outline the transition from Lomography being a movement to an actual company producing its own unique cameras? Was continuing the production of the LC-A a big part of this? What were some of the other most popular early Lomo cameras?

constantly communicate and present film photography everywhere. Although digital photography changed all our lives, Lomography still manages to attract people, especially young people, to film photography. With our products, we are able to introduce film photography to those who have grown up with only digital products and explain to them all the creative aspects. Film photography enhances a person's creativity, because you are part of a creative process.

In the early days, Lomography stood for a release from too many strict rules in photography. By telling people, "Don't think, just shoot," we were able to communicate a new way of taking photos and the element of fun was very important. Today, Lomography's emphasis is to take an experimental and creative approach to photography. Our community members are looking for an alternative attitude and they do not necessarily want to go with the mainstream.

How do some of the more high-profile cross-branded special editions come to be with partners like Sanrio and the White Stripes? Do they come to you, or is it the other way around? Do you see celebrity partnerships important to the brand?

Lomographers in general and the Lomography teams and ambassadors are very communicative and socially active people. We all love to go out, meet people, and travel a lot. To take a Lomograph means to interact with someone.

This is how most of our co-operations happen. All these partners got in contact with us and suggested a cooperation. Sometimes, like for the launch of our new Petzval art lens, we contact different artists and photographers to try the lens. And the outcome so far is fantastic.

(▲) Brass with class: The Petzval lens.

The old world of inexpensive plastic novelty cameras sometimes intersects with where Lomography is today, with regard to some of Lomo's products. How have Lomo cameras and their special effects transcended the "novelty" realm to become something more artistic and inspiring? What separates Lomo from vintage novelty cameras?

Every product we develop has a very special function. Content is the only thing we deal with. It's not about the look, vintage or new, that separates our products from vintage novelty cameras. When we develop new products and ideas, we also research techniques and technologies that do not exist anymore. And if we re-launch a camera like the LC-A or the Lubitel, which existed in the past, we always add new features and techniques to it. With the new Petzval art lens we were interested in the swirly bokeh [aesthetic quality of out-of-focus areas of an image]. We had to completely re-engineer the optics to make it work using today's camera techniques and standards.

With the "instant back" add-ons to a few of the cameras, Lomo helped spark the resurgence of the Polaroid. Why have you brought instant film into the Lomo world?

Instant photography is an important part within film photography. From the very start of Lomography, we were interested in this technique and started to develop instant products. And in future it will continue to play an important role in the world of Lomography. There is more to come, so stay tuned.

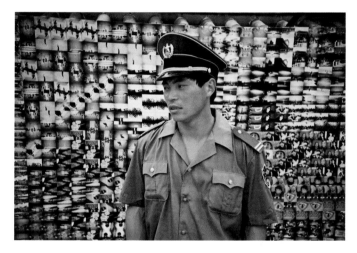

Cameras in mobile phones are used very much in line with the Ten Golden Rules of Lomography, especially the first seven rules. Do you think Lomography was a factor in phone developers loading their products with cameras?

Products like Instagram definitely were influenced by Lomography. Many existing filters and programs offer copies of a Lomographic technique, like color filters, fisheye, vignetting. Many people started to use our products after having tried out the digital copy. It makes people curious and they want to understand how something is created for real. There are ways to use our products, even if you use digital cameras. Especially our lenses enable you to work with an analog technique; for example, with the Lomography Experimental Lens Kit you can create real double exposure photos using micro 4/3 digital cameras. Even if you can create a digital double exposed image with all digital cameras, they just overlay two images with fifty percent transparency. Having a real double exposed image done as you take the photos is a totally different experience. Also, with our newly developed Lomography Art lenses, we have introduced products that serve professional photographers and creative people looking for extra possibilities on their shooting adventures. Due to their special optics, they have a unique character that contemporary lenses do not have. These lenses are able to work with many film and digital cameras.

Does Lomo have any interest in moving further into the digital realm?

Lomography will always create and develop creative products, in whatever field of photography. We already have different digital products like the Smartphone Film Scanner and the Experimental Lens Kit. But we will always be different to all those brands that try to jump on ideas through hype and afterward change to new fields. The history of Lomographic products and ideas is consistent: it always enhances creativity as can be seen on millions of photographs shown in our exhibitions and websites.

LOMO LC-A

Focus	zone
Lens	Minitar 32mm wide angle
Aperture	f/2.8
Shutter speeds	(electronic) 1/500 – 2 seconds
Focal distance	0.8m to infinity
Flash	hotshoe
Film	135

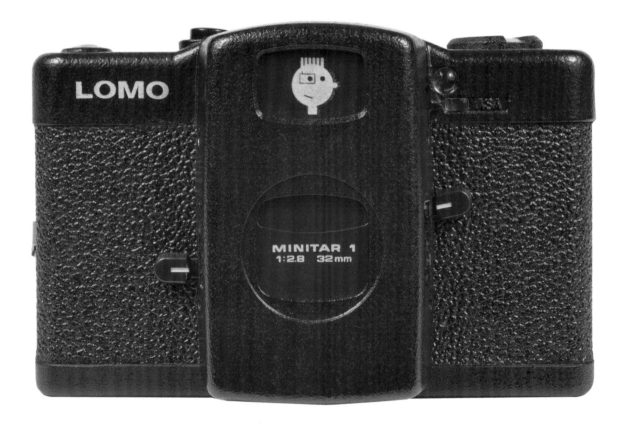

Camera: Lomo LC-A.

▲ Camera: Lomo LC-A.

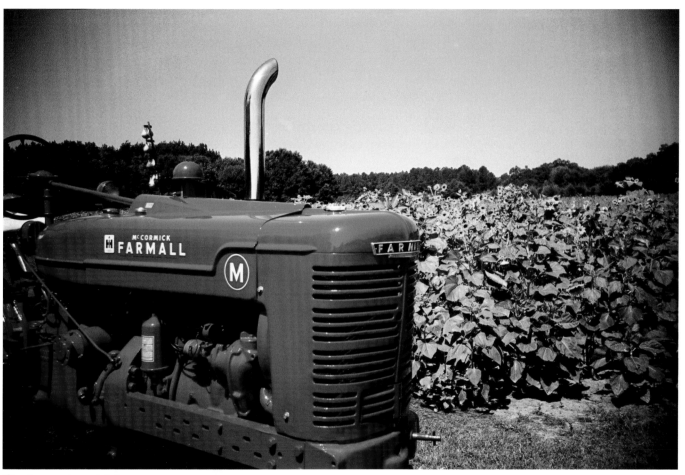

Ⓐ Camera: Lomo LC-A.

DIANA F+

Focus	zone
Lens	75mm
Aperture	f/11, f/16, f/22, f/150
Shutter speeds	1/60, bulb
Focal distance	1-2m, 2-4m, 4m to infinity
Flash	plug
Film	120

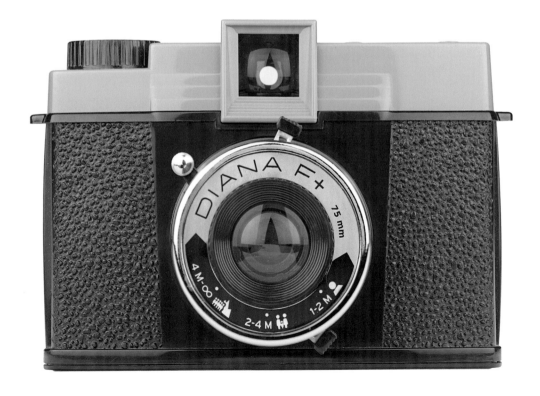

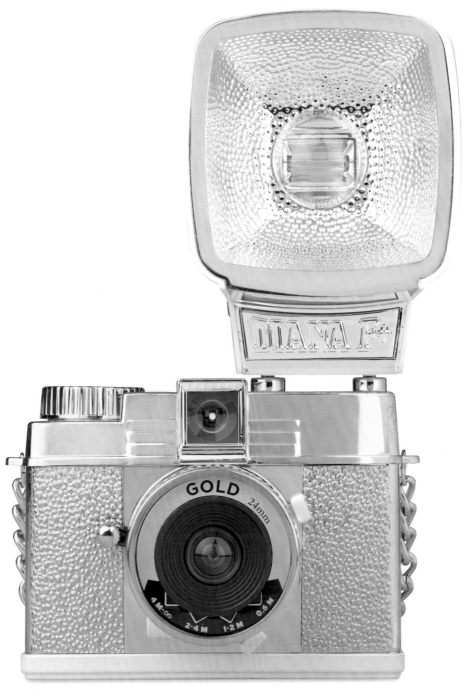

Diana F+, Gold Edition.

Camera: Diana F+.

Camera: Diana F+.

DIANA MINI

Focus	fixed
Lens	24mm
Aperture	f/8, f/11
Shutter speeds	1/60, bulb
Focal distance	0.6m to infinity
Flash	plug
Film	135

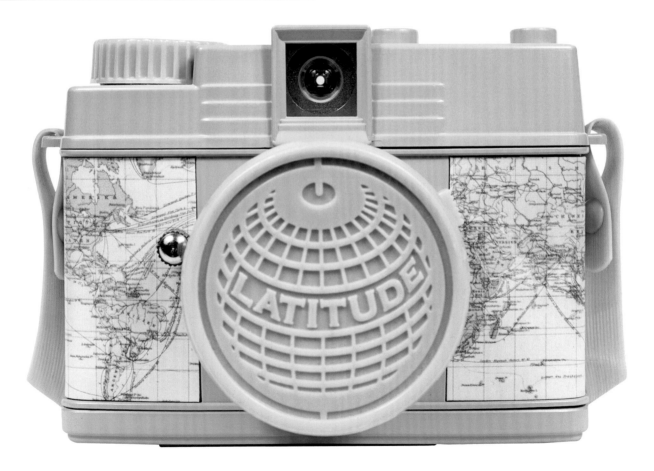

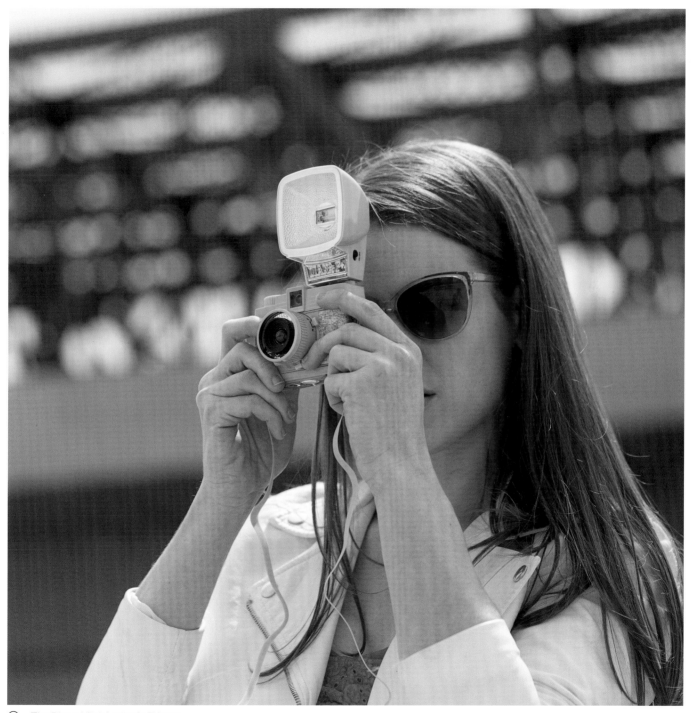

The Diana Mini: Latitude Edition.

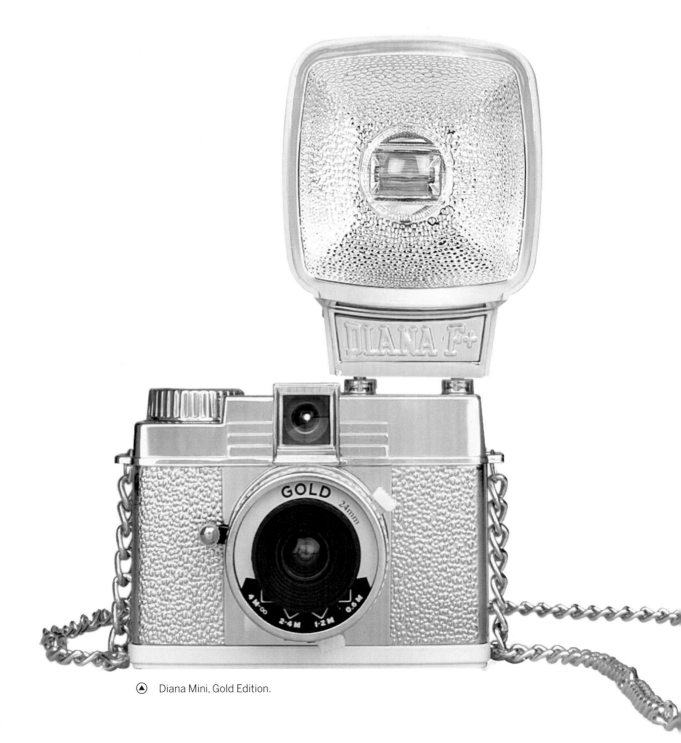

Diana Mini, Gold Edition.

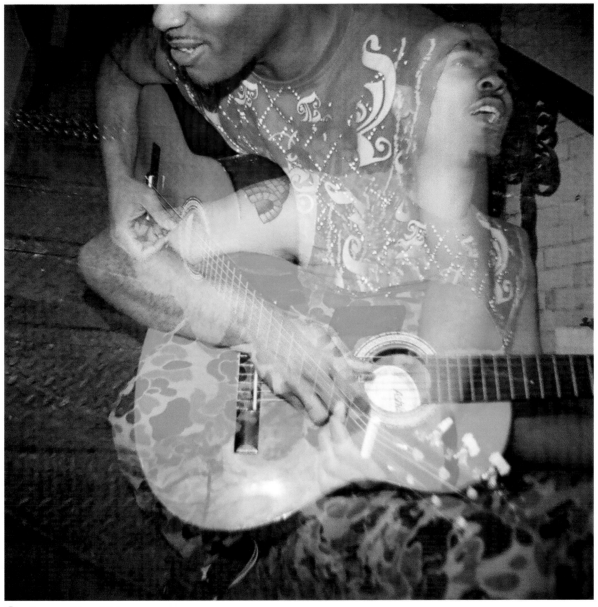

Camera: Diana Mini.

LA SARDINA

Focus	fixed
Lens	22mm
Aperture	f/8
Shutter speeds	1/100
Focal distance	0.6-1m, 1m to infinity
Flash	micro contact (Fritz the Blitz)
Film	135

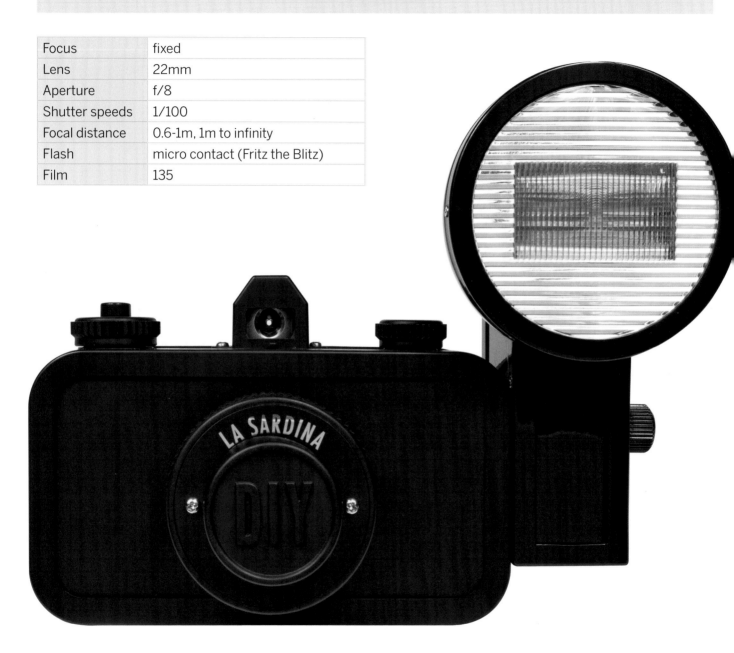

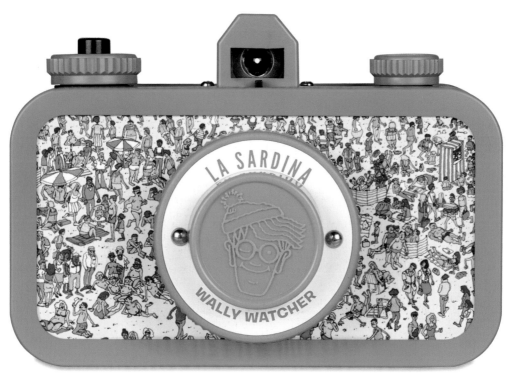

▲ La Sardina, Wally Watcher Edition.

KONSTRUKTOR

Focus	fixed
Lens	50mm
Aperture	f/10
Shutter speeds	1/80
Focal distance	0.5m to infinity
Film	135

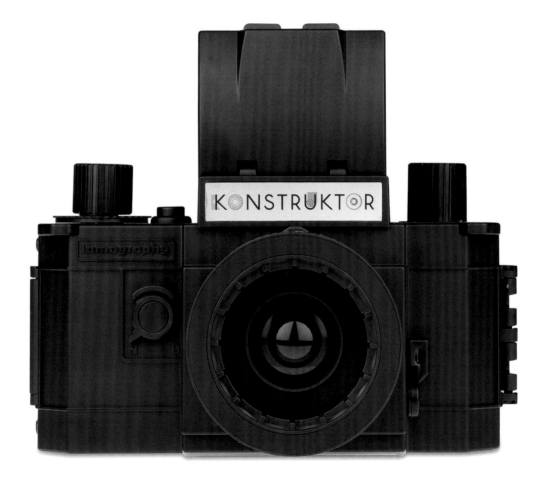

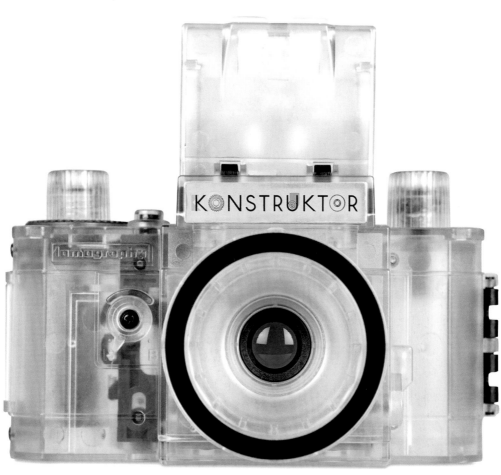

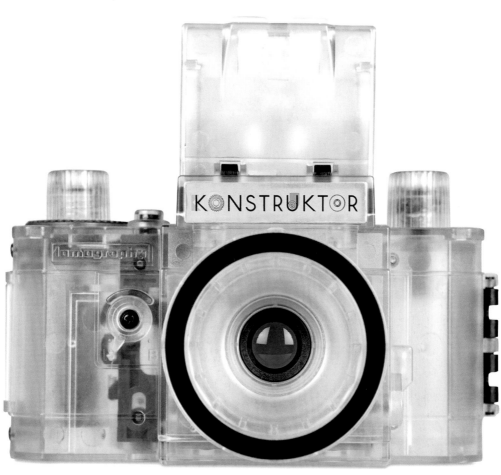 Konstruktor, Transparent Collector's Edition.

BELAIR X 6-12

Focus	zone
Lens	(interchangeable) 90mm, 58mm
Aperture	f/8, f/16
Shutter speeds	(electronic) bulb – 1/125
Focal distance	1m, 1.5m, 3m to infinity
Flash	hotshoe
Film	120

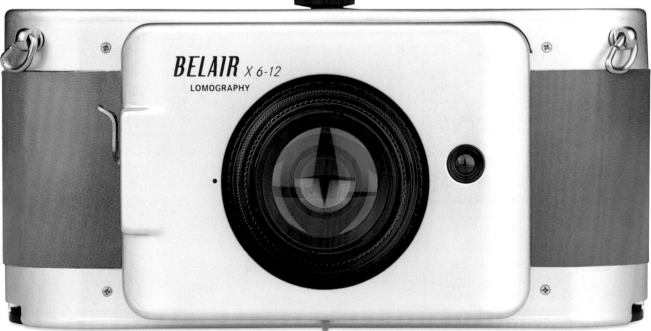

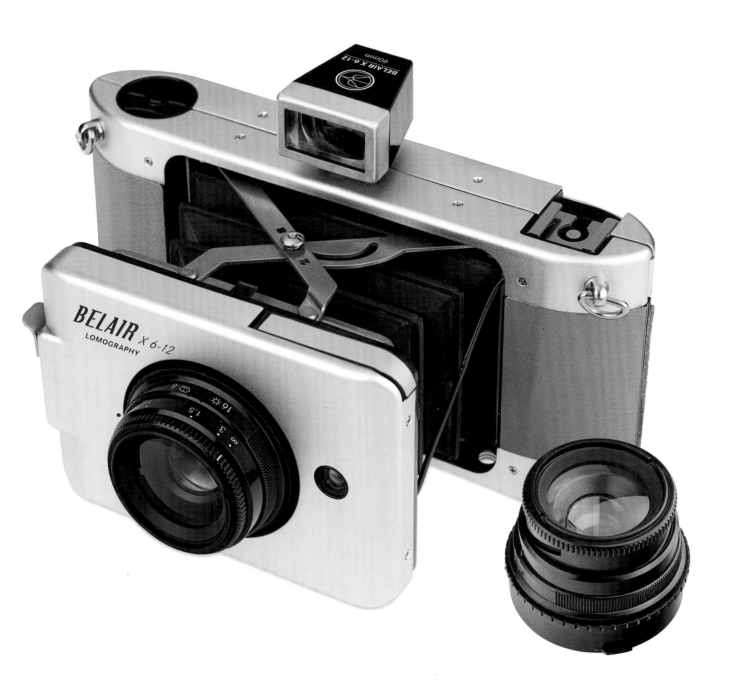

FISHEYE 2

Focus	fixed
Lens	10mm fisheye
Aperture	f/8
Shutter speeds	1/100, bulb
Flash	hotshoe
Film	135

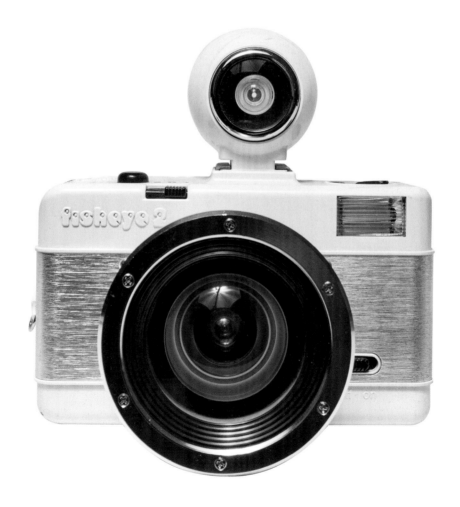

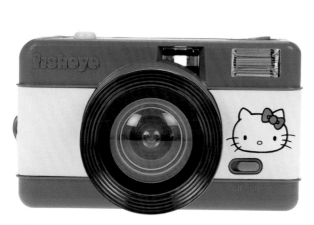

Fisheye One, Hello Kitty Edition.

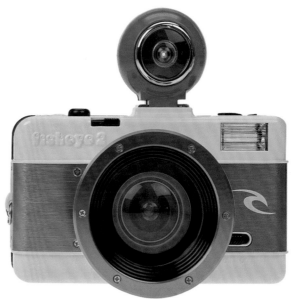

Fisheye 2, Rip Curl Edition.

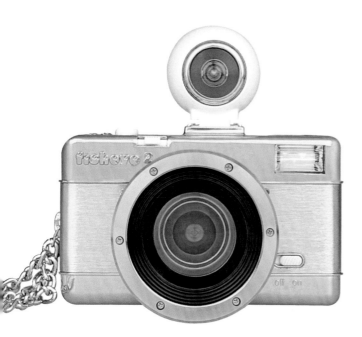

Fisheye 2, Gold Edition.

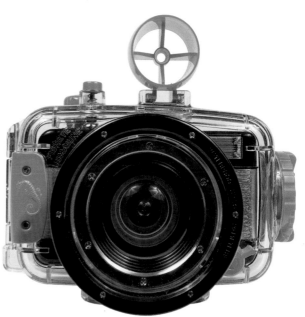

Fisheye Submarine.

⬆ Camera: Fisheye 2.

⊙ Camera: Fisheye 2.

OKTOMAT

Focus	fixed
Lens	8-in-1
Aperture	f/8
Shutter speeds	1/100
Film	135

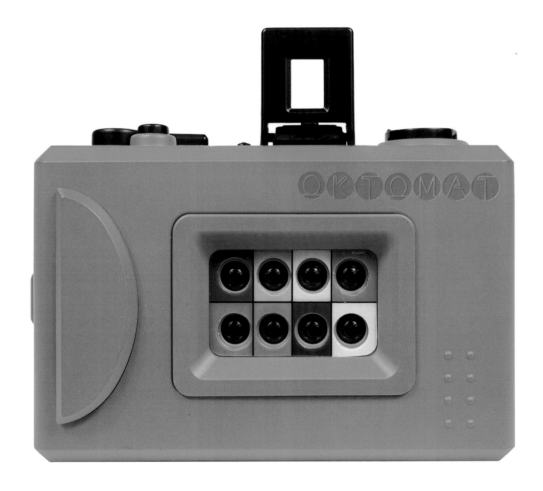

SPROCKET ROCKET

Focus	zone
Lens	30mm
Aperture	f/16, f/10.8
Shutter speeds	1/100, bulb
Focal distance	0.6-1m, 1m-infinity
Flash	hotshoe
Film	135

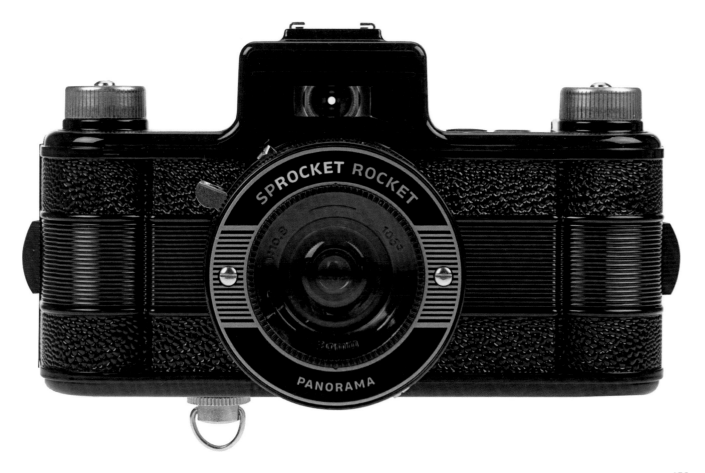

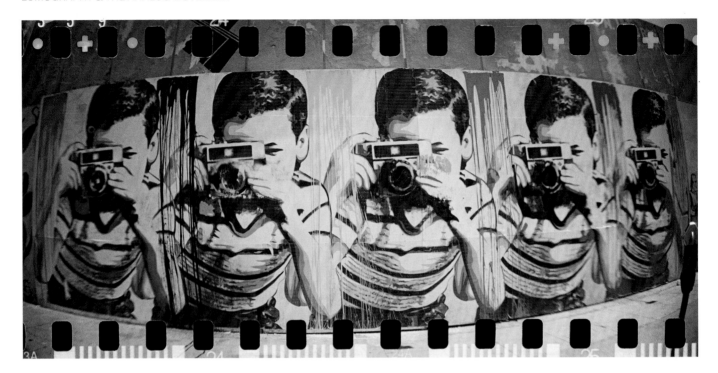

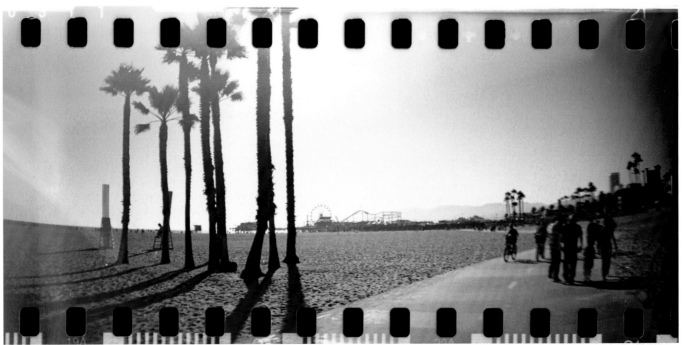

(▲) Camera: Sprocket Rocket.

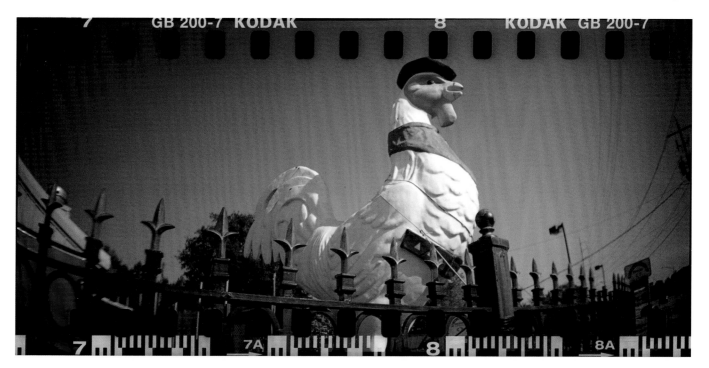

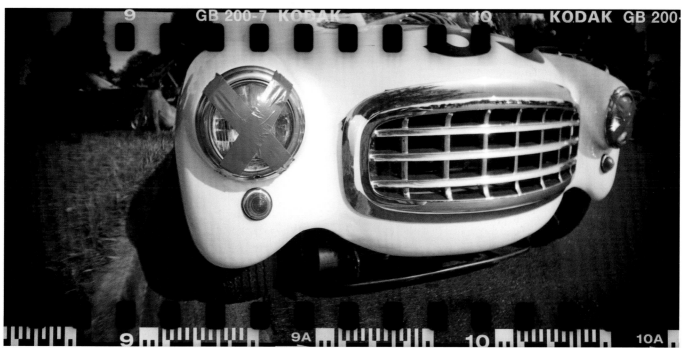

Camera: Sprocket Rocket.

HORIZON PERFEKT

Focus	fixed
Lens	28mm swing with 120° vision
Aperture	f/2.9 – f/16
Shutter speeds	1/2-second to 1/500-second
Film	135

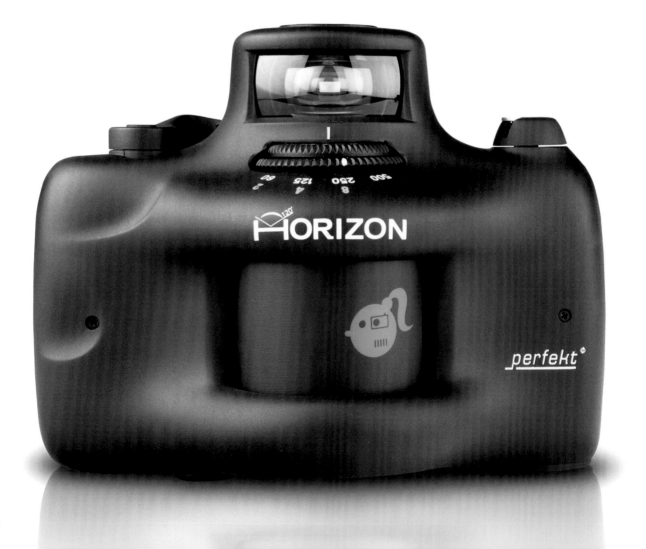

Camera: Horizon Perfekt.

SUPERSAMPLER

Focus	fixed
Lens	20mm (x4)
Shutter speeds	1/100 (standard mode: 4 images in 2 seconds, high-speed mode: 4 images in 0.2 seconds)
Focal distance	0.3m to infinity
Film	135

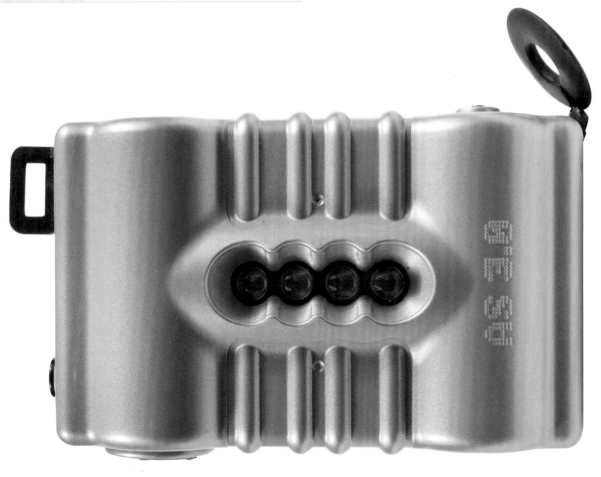

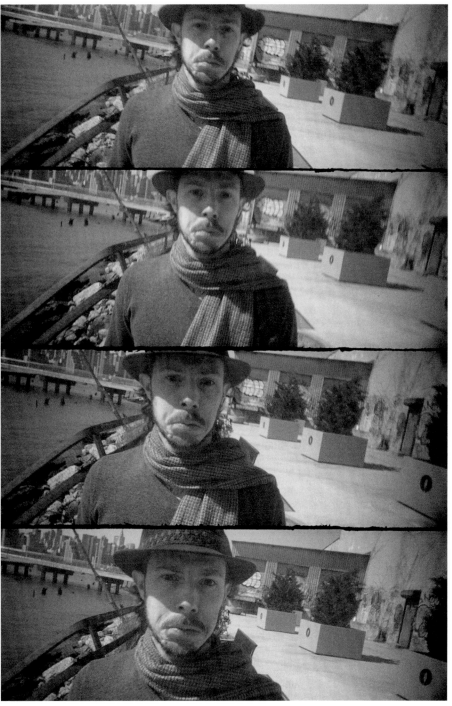

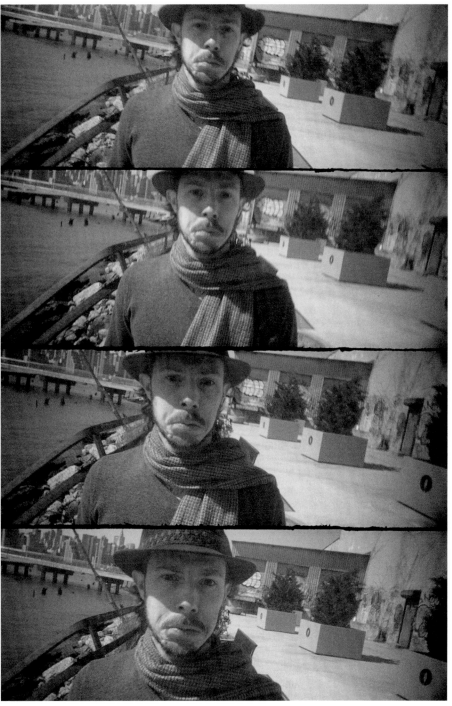 Camera: Supersampler.

COLORSPLASH

Focus	fixed
Lens	28mm
Aperture	f/8
Shutter speeds	1/125, bulb
Focal distance	1m to infinity
Film	135

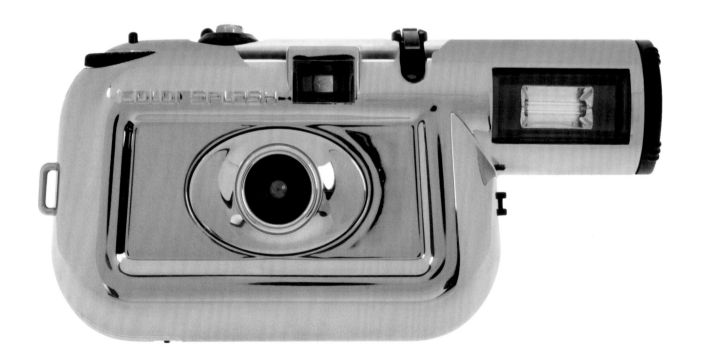

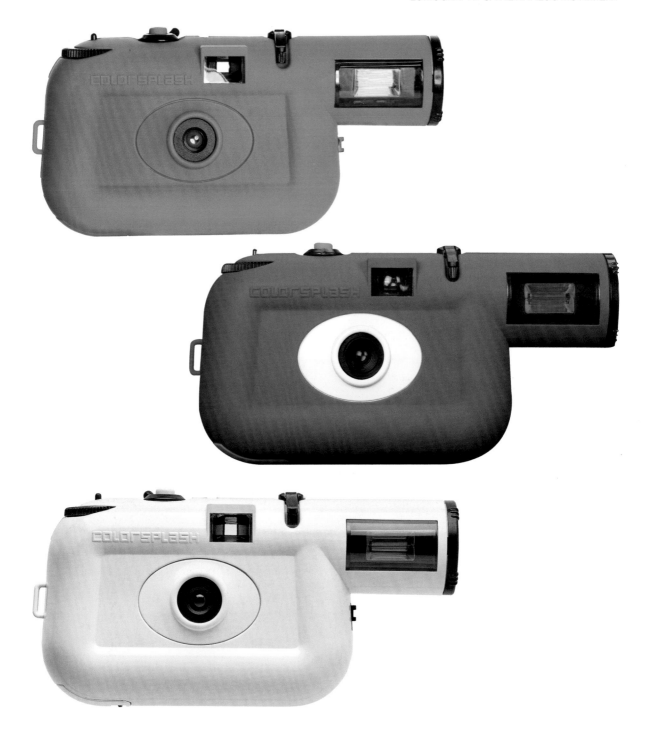

SPINNER 360°

Focus	fixed
Lens	25mm
Aperture	f/8, f/16
Shutter speeds	between 1/125 and 1/250
Focal distance	1m to infinity
Film	135

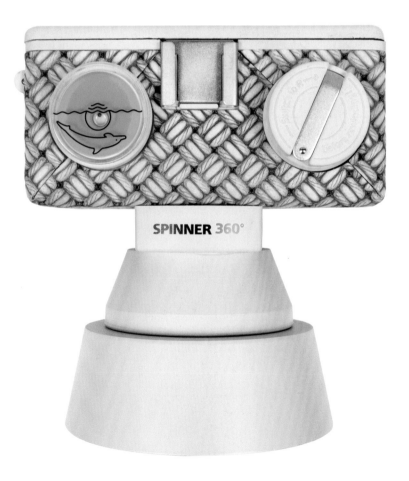

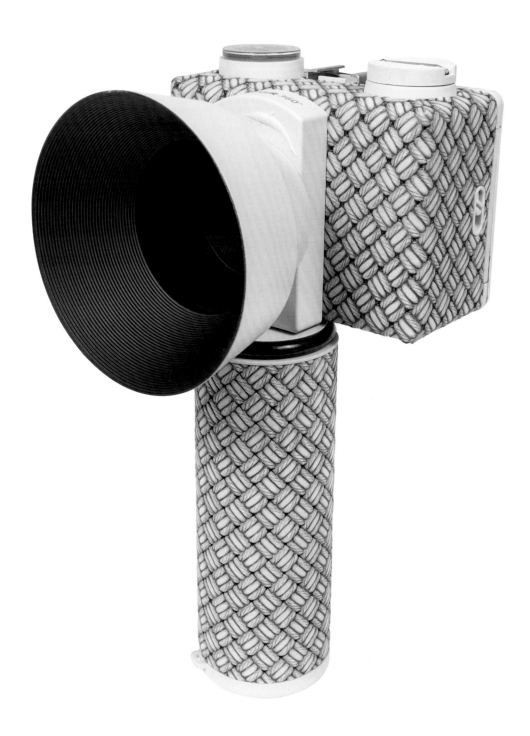

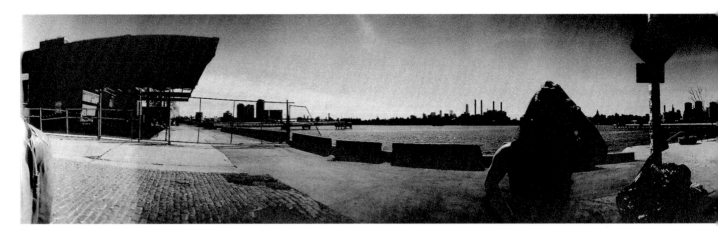

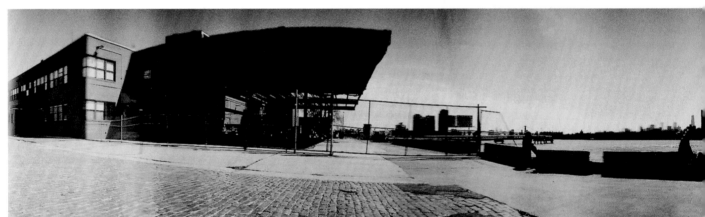

⊙ Camera: Spinner 360°.

JACK HOLGA (120CFN)

Focus	zone
Lens	60mm
Aperture	f/8, f/11
Shutter speeds	1/125, bulb
Focal distance	1m, 2m, 6m, 10m to infinity
Flash	built-in with four filters
Film	120

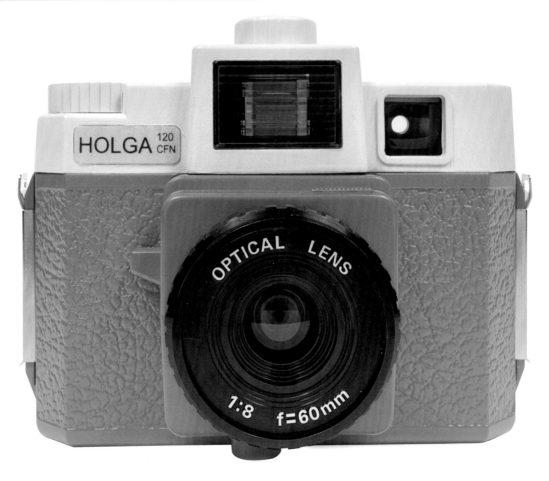

Accessories: titanium fisheye adapter lens; three plastic lens filters (one solid red, two colored soft surround); exclusive "peppermint" lens filter; plastic filter mount; *The World Through a Plastic Lens* softcover book.

MEG DIANA+

Focus	zone
Lens	75mm
Aperture	f/11, f/16, f/22, f/150
Shutter speeds	1/60, bulb
Focal distance	1 – 2m, 2 – 4m, 4m to infinity
Flash	ring
Film	120

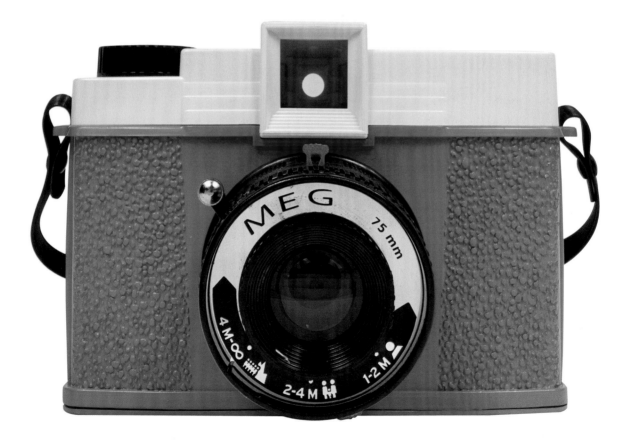

Accessories: ring flash with colored filters and hot shoe sync chord; "peppermint" mask filter; *Diana Vignettes* hardcover book.

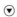

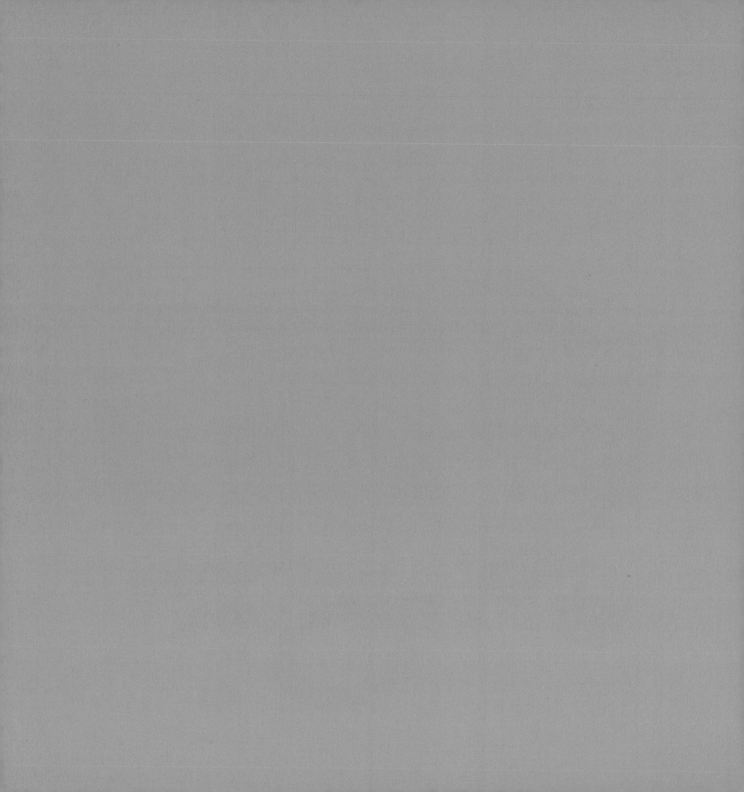

INSTANT CAMERAS:
THE RISE, FALL
& RESURGENCE
OF POLAROID

POLAROID: THE LOOK OF INSTANT GRATIFICATION

The word "Polaroid" evokes genuine nostalgia that reaches back to 1948 when the Land Camera, the first camera capable of providing pictures more or less instantly, hit the market. Edwin Land and the team he created at Polaroid established an indelible legacy on international visual culture and in more ways than one identified expectations and technological desires that foreshadowed the role of the image in the age of the Internet and social media.

A bona fide visionary, Land's earliest inventions, starting with his first patent in 1929, dealt with polarizers and how they could be applied practically to headlights, car windshields, windows, and 3D glasses. But, so the lore goes, he hadn't framed his work in photography until a 1943 family vacation to New Mexico where he took a photograph of his daughter who asked why she had to wait to see the image.

It took years of research and development for Land to achieve the Polaroid camera the world embraced. The road to a click-and-print form of photography was rooted in a distinctive American post-war mentality that presumed technology could solve all problems. This techno-utopian perspective also carried over to how these cameras were marketed and sold.

The Model 95 Land Camera sold 900,000 units between 1948 and 1953. But professional photographers were highly critical, considering the camera a novelty for amateurs. Land countered this by putting Ansel Adams on a consulting retainer, starting in 1949 at $100 USD per month, which continued until the famed photographer retired. Adams delighted in the Polaroid experiment and was a keen advocate and technical advisor, helping to bring many other professional photographers on board with the medium's latest phase.

There's a reason why Steve Jobs looked up to Land—both men understood the importance of marketing and design when promoting a product, which at its core sprung from a corporate culture that all employees identified with and their enthusiasm and devotion propelled everything else. In 1957, Meroë Marston Morse, who had worked with Land since 1944, wrote a memo to a new hire that encapsulates the primary directive behind the work that was taking place at Polaroid: "make our kind of photography an indigenous American art."

2012 marked the 75TH anniversary of the Polaroid brand, but the company stopped producing instant film cameras in 2008 (the same year the company also filed for bankruptcy). Though Polaroid still exists, it no longer makes film, focusing only on digital cameras. Even so, the heyday of instant film cameras did in fact create something close to "an indigenous American art" made accessible to millions of people. As the examples demonstrate, that popularity found footholds in numerous other products and brands that all wanted to be associated with the same thing: "Instant photography at the push of a button!"

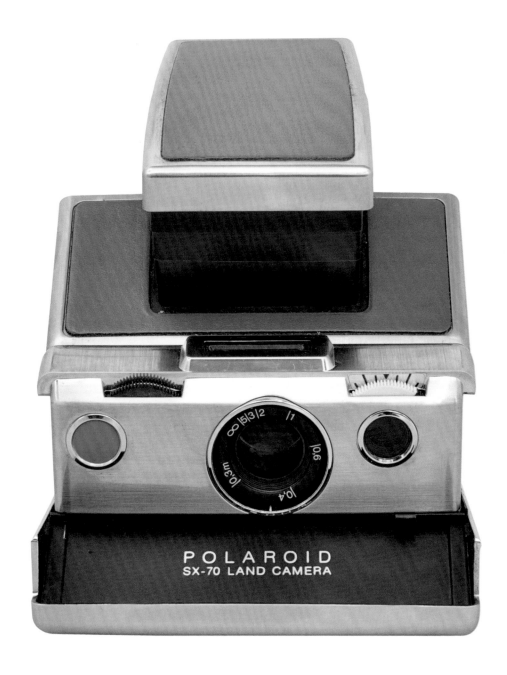

Camera: Polaroid 636 Close up.

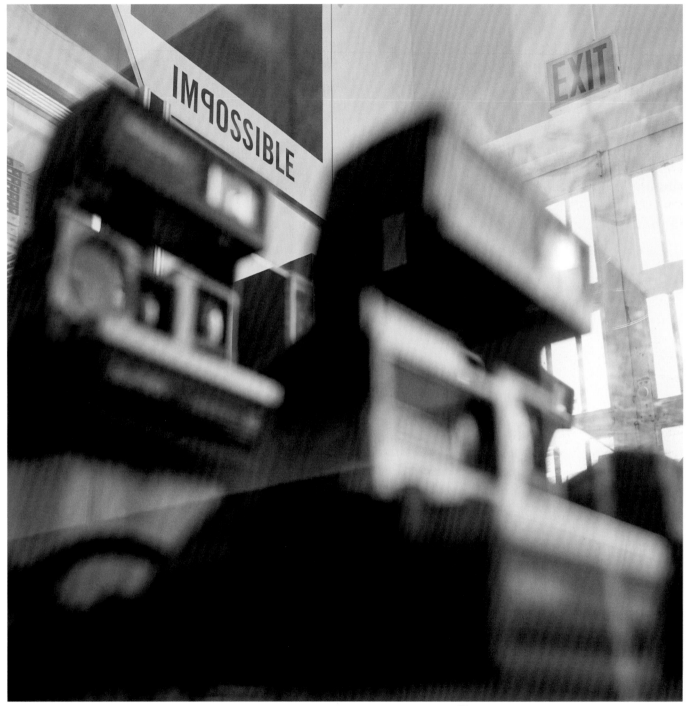

The New York City Impossible Project store.

THE IMPOSSIBLE PROJECT: POLAROID'S SAVING GRACE
INTERVIEW WITH CREED O'HANLON, THE IMPOSSIBLE PROJECT'S CEO

In 2008, Florian Kaps and André Bosman started The Impossible Project when they purchased a Polaroid factory in Enschede, The Netherlands, in an attempt to save instant film. Using the facility and the expertise of former Polaroid employees, The Impossible Project created new materials to replicate the instant camera experience—something Polaroid was no longer pursuing as part of its business. In doing so, The Impossible Project resurrected an analog medium in the digital age, proving that instant photography is about much more than nostalgia.

With its inception in 2008, the Impossible Project prevented 300 million functioning Polaroid cameras in circulation around the world from becoming obsolete. Why did the project's founders feel that this was important? What is it about instant cameras that was worth saving?

A little known fact: the simple processing of a single integral instant film, such as Impossible's Color film for Polaroid-type 600 or SX-70 cameras, is one of the most complex man-made chemical reactions ever devised, involving over 5,000 separate actions.

It is, in short, pretty close to miraculous and it contributes to the sense of wonder that everyone still has watching an instant film emerge and develop. With well over 300 million Polaroid cameras in the world, there was a very sound business argument for ensuring this experience remained available for future generations. Our current film sales indicate that Impossible's founders were right—despite digital, people still love this medium.

What were the biggest challenges in recreating Polaroid instant film? In what ways did the learning process influence the Impossible Project to create its own unique brands of instant film?

Any perception that when Polaroid left their last factory in the world, in Enschede, they left behind all the machinery and know-how to make film is wrong. We had a residue of assembly know-how and some rudiments of alternative chemistry, mostly Agfa-based. And that's it. Everything we have achieved so far was hard won, hard learned. Now, we're successful enough to hire people like Stephen Herchen, a former CTO of Polaroid, who worked alongside Polaroid founder Edwin Land, and a founder of Zink!, as Impossible's CTO, and he is bringing another level of refinement to our line of film products.

Impossible co-founder Florian Kaps began working with Lomography before starting the Impossible Project, and it's been interesting to note the resurgence of analog film all happening during roughly the same period.

What do you feel is the catalyst for this change? Do you think people are responding indifferently to digital?

People simply don't categorize themselves as analog or digital. Their lives are immersed in different ways in digital but they choose—and sometimes long for—the slower, more physically "present" experiences, which are usually expressed in analog, whether it's music, books, or photography. It isn't reactive or a "trend" (i.e. retro or vintage) driven decision, rather it's a natural balancing of the physical, emotional and explorational with the efficient, fast, and immersive. Where Florian was evangelical, and possibly a little dogmatic, about analog, Impossible today is more equitable, more accepting that its place in everyone's lives is individual.

Now several years into the project, are you surprised by the demand for your products the world over?

For all the reasons noted, no. We're not at all.

Seeing how Impossible sells refurbished Polaroid cameras, are there any plans to develop new Impossible cameras or other hardware?

We have already launched the Instant Lab, with which you can turn any digital image stored on your iPhone 4, 4S, 5 or 5S, or iPod Touch (4th and 5th Generation) into a beautiful, classic-looking analog instant photograph—in the square format frame made famous by Polaroid. And yes, it's a camera not a printer! We are also working on

two instant cameras, which should be launched in the first half of 2015.

What is the origin of the project's name? Why was it dubbed "Impossible Project"?

The name was taken from when Florian wanted to buy the last factory to create a future for instant film—Polaroid's management told him that it would be impossible for him to do and he would never produce any film in this factory. He heard the same response five times and that's when he decided on the Impossible name.

There is also a quote from Edwin Land, the creator of Polaroid, which states, "Never undertake a project unless it is manifestly important and nearly impossible," which lends itself perfectly to us.

LOONEY TUNES TAZ INSTANT CAMERA

Manufactured in United Kingdom. Year: 1999. Flash: built in.

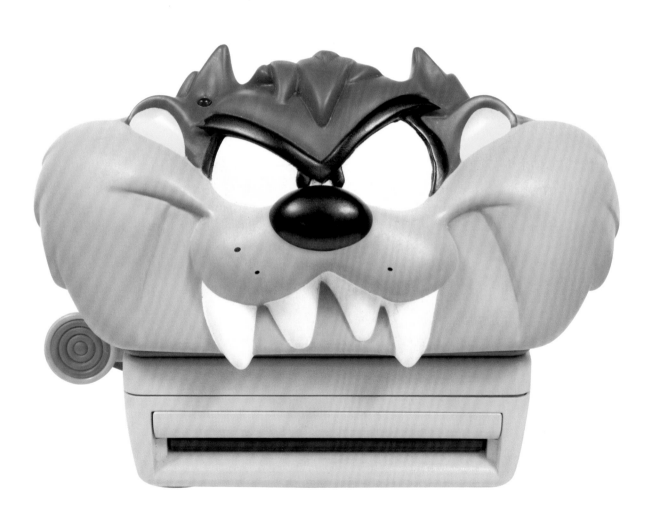

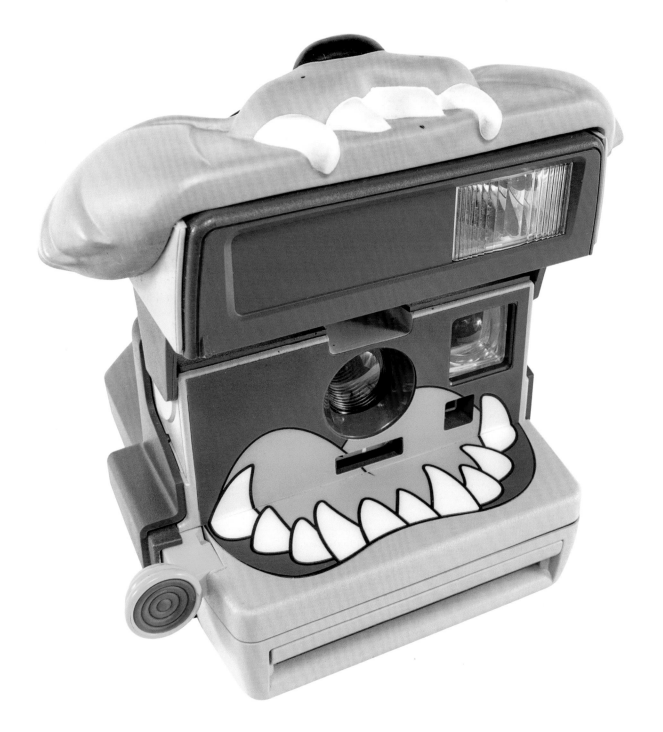

HELLO KITTY INSTANT CAMERA

Manufactured in United Kingdom for Tomy. Year: 1998. Flash: built in.

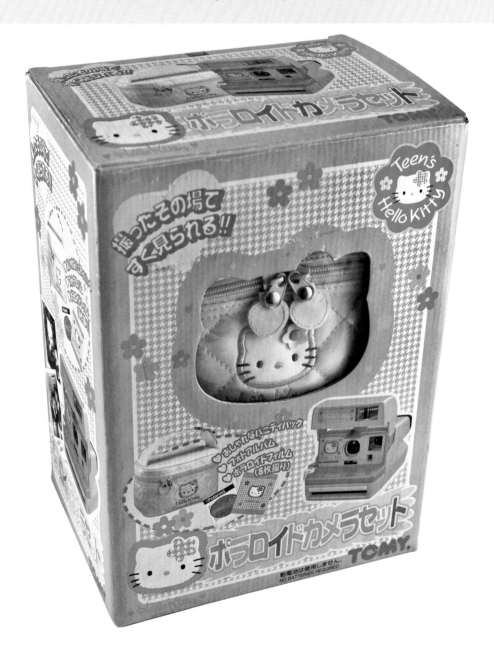

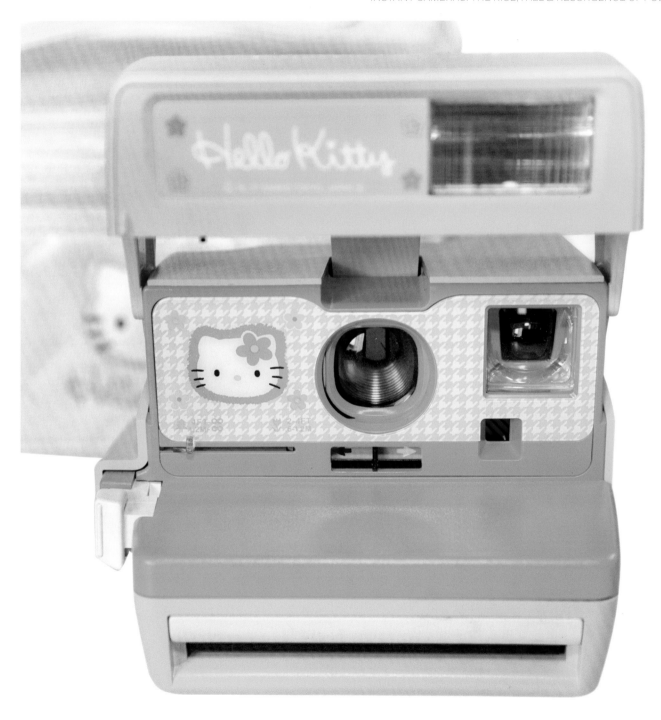

BARBIE INSTANT CAMERA

Year: 1999. Flash: built in.

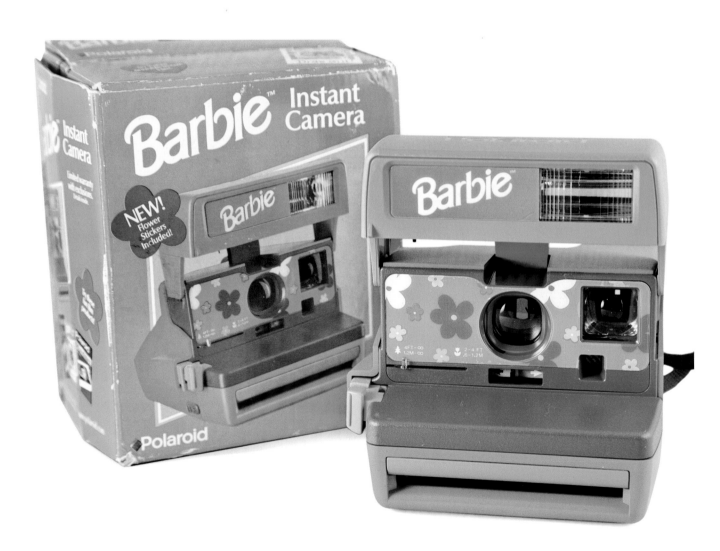

KODOMO NO OMOCHA INSTANT CAMERA

Manufactured in United Kingdom for Tomy. Flash: built in.

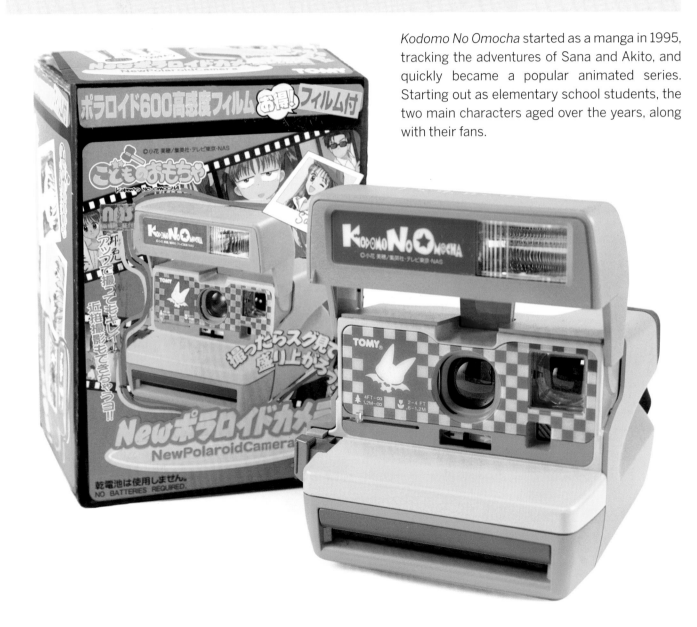

Kodomo No Omocha started as a manga in 1995, tracking the adventures of Sana and Akito, and quickly became a popular animated series. Starting out as elementary school students, the two main characters aged over the years, along with their fans.

KODOMO NO OMOCHA INSTANT CAMERA

Manufactured in United Kingdom for Legoland. Year: 1997. Flash: built in.

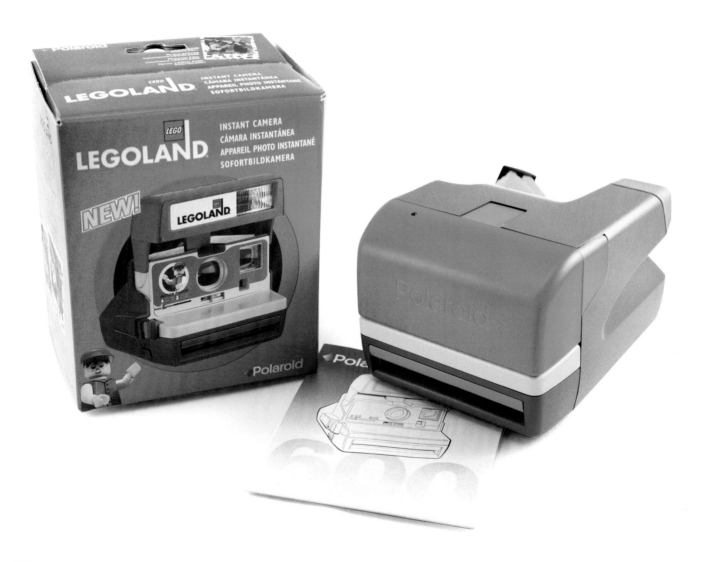

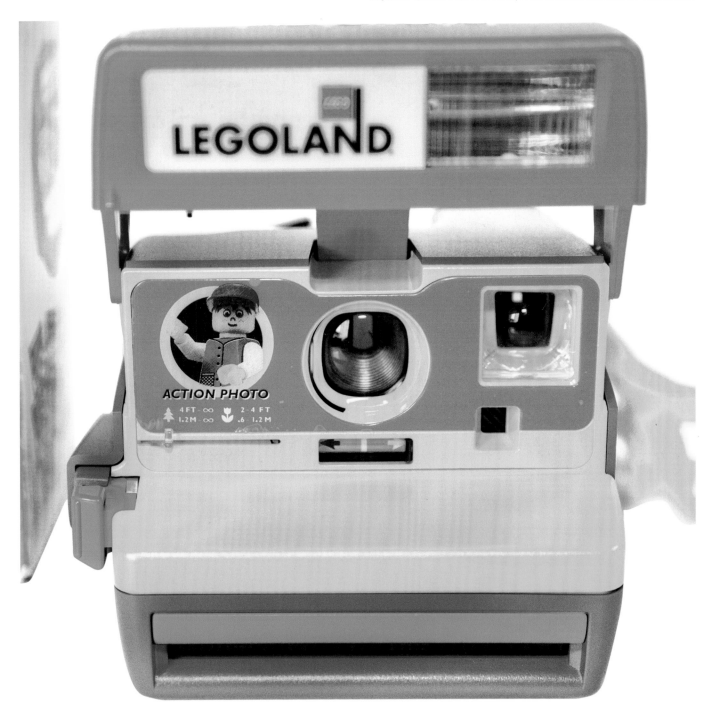

JAPANESE
CAMERA
CULTURE

SUPERHEADZ / POWERSHOVEL

In 1996, Tokyo-based Hideki Omori built an Internet business importing and customizing Lomo and Holga cameras from abroad. When these cameras became increasingly harder to find, he decided to start making his own. This is the origin story of Powershovel and SuperHeadz. It's hard to understand the difference between the two entities with equally memorable names. According to the website: "We have two names, SuperHeadzINaBabylon and PowerShovel. SuperHeadz is one of the most radical creative teams in Tokyo, where we design, edit and plan to collage fragments of this city. PowerShovel is our corporate name and it is used for our more-business-oriented part. They are like two sides of a coin. They never face each other, like light and shadow, but they reverberate in unison as flower and water do."

The variety of toy cameras that SuperHeadz/Powershovel have produced is exemplary—the Golden Half, the Blackbird Fly, the Digital Harinezumi. People gravitate to the cameras as objects, which is fitting for the company's ethos. In a 2008 interview with *PinMag*, when asked what advice he had for first-time camera users, Omori answered: "First of all, it's best to choose a camera by its appearance. Surely it is okay to choose one by the atmosphere of each camera's photos. However, going for the appearance will make you want to carry it around with you every day and it will encourage you to take more pictures."

Powershovel/SuperHeadz is definitely a camera cult of personality. While some of their sales copy might treat the cameras more like accessories to accent users' lives, it's clear that the company wants its fans to appreciate that each camera has its own individual charms. Take the Last Camera: released in 2012, it's an analog camera you have to build yourself. The company doesn't understand the camera as an instrument of precision but as a "sketch book, something with which you easily record bits of your life."

DIGITAL HARINEZUMI

Focus	auto
Lens	35mm
Aperture	f/3-4
Focal distance	1m to infinity
Picture quality	3MP
ISO modes	100/800
Image size	1600×1200 (JPEG)
Video size	640×480 (AVI)
Memory	MicroSD

SuperHeadz's Harinezumi (version 2, below) is a digital still and video recorder that imitates the warmth of vintage Super 8 film.

⊛　Camera: Harinezumi 2.

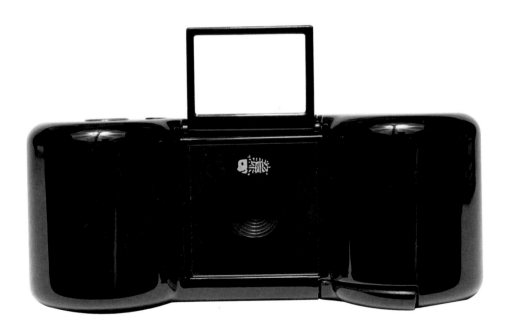

DEMEKIN

Focus	fixed
Lens	1:13.5
Aperture	f/8.9
Shutter speeds	1/100
Focal distance	1m to infinity
Film	110

A pocket 110 by SuperHeadz with fisheye lens.

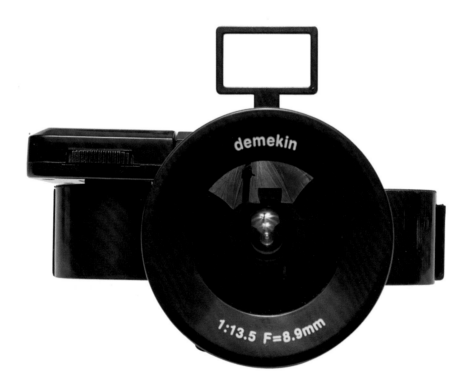

BOOK CAMERA

Focus	fixed and close-up
Lens	23.1mm
Aperture	f/8
Shutter speeds	1/80
Focal distance	(normal): 1.5m to infinity, (close up) 25cm
Film	110

SuperHeadz's answer to the *Websters Dictionary* (page 84). Available in models "Young Deer" and "Classic Red."

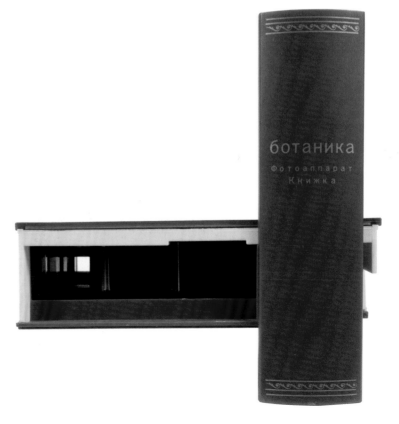

GAKKENFLEX

Focus	manual
Lens	twin reflex
Aperture	f/11
Shutter speeds	1/125
Focal distance	50cm to infinity
Film	135

Gakken is a Japanese company known for making mini build-it-yourself kits of various kinds: a theremin, a desktop robotic cleaner, a walking rhino, and this miniature twin lens reflex camera.

Ⓐ Camera: Gakkenflex.

BLACKBIRD, FLY

Focus	manual (scale)
Lens	33mm wide angle twin reflex
Aperture	/7 and f/11
Shutter speeds	1/125, bulb
Focal distance	0.8ft, 1.5ft, 2ft, 2.5ft, 3ft, 4ft, 5ft, 10ft to infinity
Flash	hotshoe
Film	135

The SuperHeadz Blackbird, Fly does indeed have a comma in it's name. Why? We didn't ask. Available in five different color varients and with masks for three different formats: normal (24mm × 36mm), square (24mm × 24mm), and large square (36mm × 36mm).

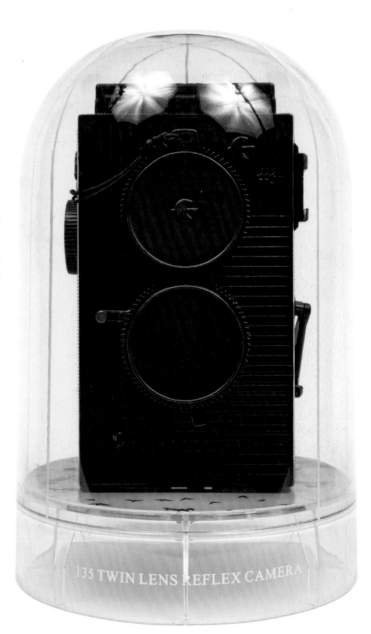

⊕ Camera: Blackbird, Fly.

SHIRONEKO HOLGA

Focus	fixed
Lens	35mm
Aperture	f/8
Shutter speeds	1/100
Flash	built in
Film	135

A collaborative effort with Holga, the SuperHeadz Shironeko (white cat) is a camera specifically made for photographing felines. With each push of the button the LED lights on the front of the camera flash and the camera emits one of a few meowing sounds.

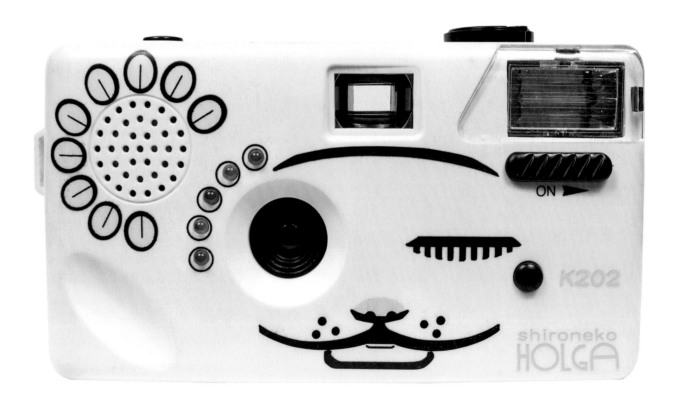

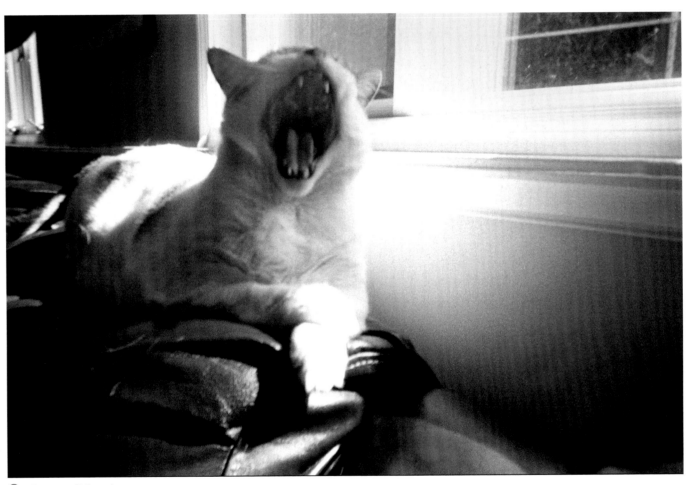

⊙ Camera: Shironeko.

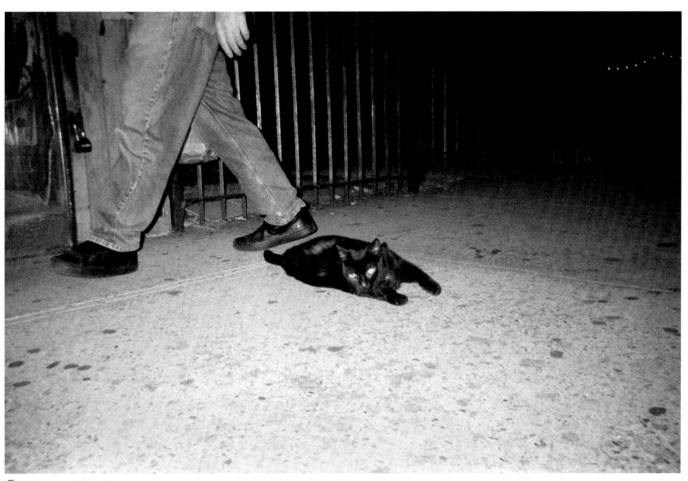

▲ Camera: Shironeko.

NECONO DIGITAL CAMERA

Focus	auto
Lens	35mm
Focal distance	1m to infinity
Picture quality	3MP
ISO modes	100/800
Image size	2058×1536 (JPEG)
Video size	640×480 (AVI)
Memory	MicroSD

Designed from the cat illustrations of Swedish ceramic designer Lisa Larson, the Necono is a tiny digital camera with magnetic feet—perfect for capturing candids of your pets. A "monitor ground" with LCD is sold seperately.

▲ Camera: Necono.

GOLDEN HALF

Focus	fixed
Lens	22mm
Aperture	f/8, f/11
Shutter speeds	1/100
Focal distance	1.5m to infinity
Flash	hotshoe
Film	135

Beautifully sized (fits in the palm of your hand) and inspired by the classic Holiday Brownie, the SuperHeadz Golden Half takes two images per frame.

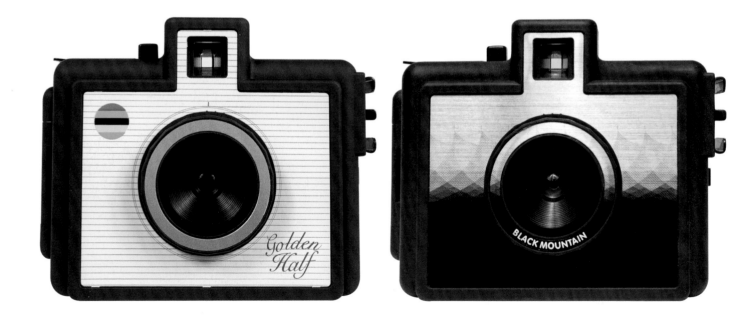

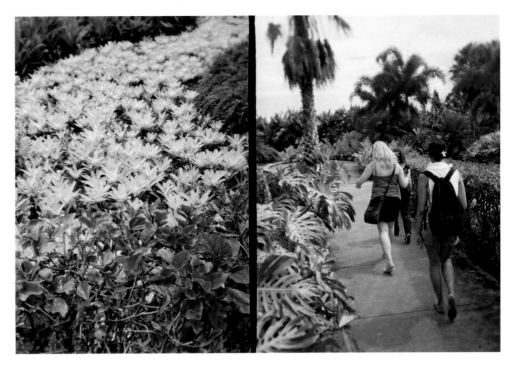

⊕ Camera: Golden Half.

ULTRA WIDE & SLIM

Focus	fixed
Lens	22mm
Aperture	f/11
Shutter speeds	1/125
Focal distance	1.2m to infinity
Film	135

The SuperHeadz Ultra Wide and Slim line comes in a variety of models—pictured here are the Angel and Devil. Inspired by the Vivitar Ultra Wide and Slim, this modern plastic point and shoot has a wide angle lens that tends to produce vibrant results.

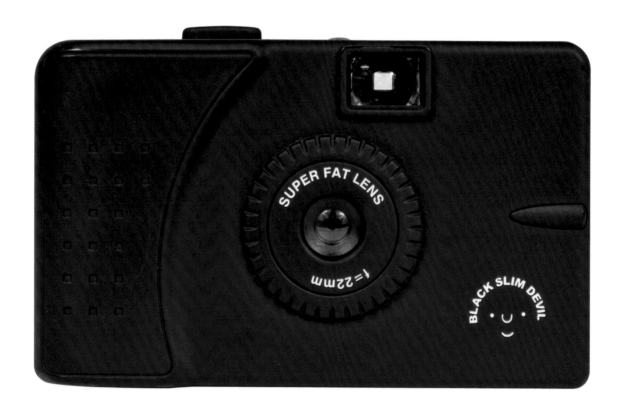

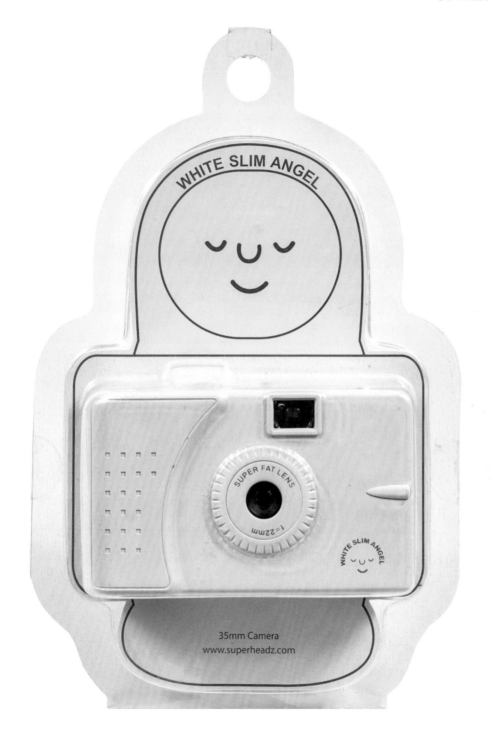

Camera: Slim Angel.

 Camera: Slim Angel.

⊙ Camera: Slim Devil.

⬆ Camera: Slim Devil.

LAST CAMERA

Focus	fixed
Lens	22mm and 45mm
Shutter speeds	(22mm) 1/125, (45mm) 1/100
Camera back	interchangeable: normal/light leak
Film	135

The Last Camera by SuperHeadz is a build it yourself camera kit with interchangeable lenses and an optional "light leak" back.

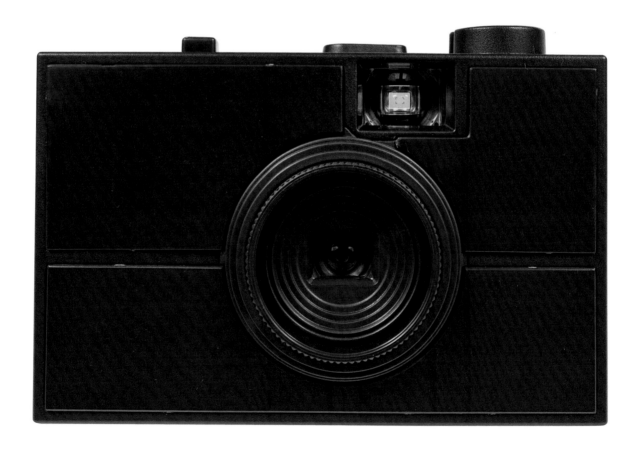

FUUVI NANOBLOCK

Focus	auto
Aperture	f/2.8
ISO	100
Picture quality	2MP
Image size	2048×1536 (JPEG)
Video size	720×480 (AVI)
Memory	MicroSD

Similar to Legos only much, much smaller, the Fuuvi Nanoblock is a customizable digital camera—you're encouraged to add to it with your own Nanoblocks.

FUUVI BISCUIT

Focus	auto
Aperture	f/2.8
ISO	100
Shutter speeds	1/33
Picture quality	2MP
Image size	2048×1536 (JPEG)
Video size	720×480 (AVI)
Memory	MicroSD

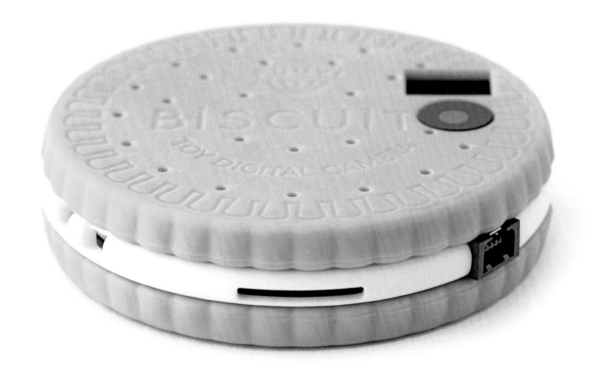

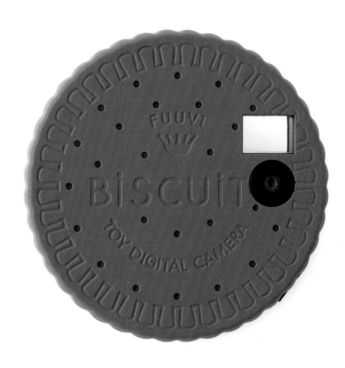

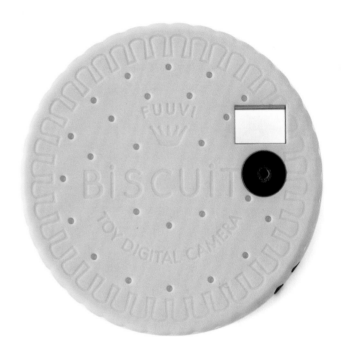

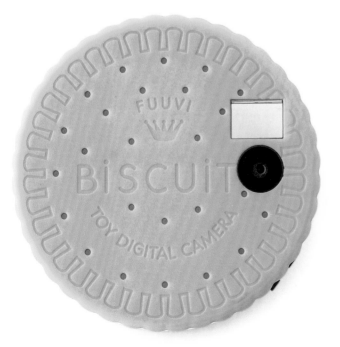

FUUVI PICK

Focus	auto
Aperture	f/2.8
ISO	100
Shutter speeds	1/33
Picture quality	2MP
Image size	2048×1536 (JPEG)
Video size	720×480 (AVI)
Memory	MicroSD

FUUVI JUICE BOX

Focus	fixed
Lens	28mm
Aperture	f/9.5
Shutter speeds	1/100
Focal distance	1m to infinity
Film	135

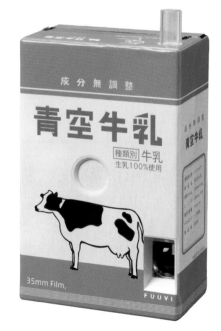

DIGITAL TOYS

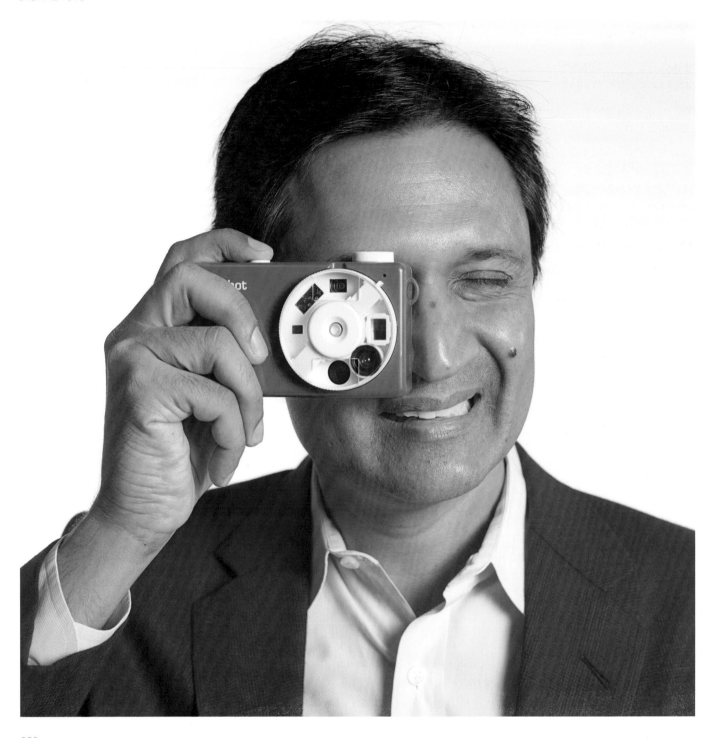

MR. BIGSHOT
INTERVIEW WITH SHREE K. NAYAR, INVENTOR OF BIGSHOT CAMERA

As Shree K. Nayar, the T.C. Chang Professor, Computer Science, at Columbia University, explained to a TEDx audience on October 25, 2013, creating the Bigshot was the result of thinking about "how one could leverage the enormous appeal of cameras to address a social issue, namely education." Nayar credits the documentary film *Born Into Brothels*, and the filmmakers' decision to give their subjects cameras, as the impetus for coming up with one very convincing solution for using cameras to excite kids about learning: a kit camera that teaches users about science, art, and culture. But Nayar's ultimate inspiration was his father—"an engineer's engineer"—and all the time they spent together tinkering on anything that needed repair. For Nayar, appreciating being able to make and fix things imparted to him lessons that have shaped his thinking more than any class he has ever taken. The Bigshot is meant to be such an invaluable and indelible experience for every child who has the opportunity to build the camera, use it, and share his or her creations, making every user a "big shot."

As a computer science professor, you specialize in advanced computer vision systems. In layman's terms, what exactly does that mean and how does it relate to you developing the Bigshot?

It's very simple: we are in the business of building machines that can see, machines that emulate human vision. Facial recognition in cameras, tracking systems for surveillance, reconstructing 3D models for navigation—everything we can do with our eyes we try to develop algorithms that accomplish the same.

I came to Columbia in 1991, and started the Computer Vision Lab. What was interesting to me in the early '90s was that in trying to replicate the functions of the eye, all the cameras we were using were developed for television or photography. I got interested in a side stream: How to produce images better than the eye can produce? Like panoramic images in a single shot and multispectra images that are richer in color. This field is known as computational imaging—it's become a very active field. The idea is to develop cameras that produce new forms of visual information.

In 2007, having primarily focused on high-end applications of imaging, I thought: Wouldn't it be nice to redesign the camera to have a wider social impact, especially in an educational context? That was the genesis of Bigshot.

What is your personal relationship to cameras? Do you collect them? Do you take lots of photographs?

I love vision because it involves not just technology but light, the aesthetics of light, but I am not much of a photographer. I do have Polaroids, old Leicas, my dad's old camera. But I am not a collector. I am not an early

the website, which teach all the concepts related to the different aspects of the camera. For example, a power generator is not essential for a camera but it lets us demonstrate how gears work.

The whole process was a life experience for me, allowing me to pretend to be a designer. We made prototypes in different colors, the colors of M&Ms, and did tests in New York, Bangalore, Vung Tau, and Tokyo. We took great pains for a young audience to be treated as if they are older in order to challenge them.

In terms of using technology to empower children, there seems to be some crossover between Bigshot and the One Laptop Per Child project. Did that model at all influence the development of Bigshot's mission?

I looked at them very carefully but it wasn't clear if the model was the right one for Bigshot. At first I thought about just being a nonprofit. But because it involves hardware I'd be out looking for money all the time. So I decided that if I incentivize everyone with a strong business model, and licensed the technology, I could use royalties we receive from camera sales to give away cameras to children in underserved communities.

adopter of anything. I am someone wary of the learning curve associated with new gadgets. In some ways, Bigshot captures that in spirit. I'm trying to demystify the technology. That's why it comes as a kit. Today, kids play with software constantly but have no idea what happens in terms of hardware. We want the next generation to be able to build stuff, not just use stuff.

What was the process behind designing the Bigshot? Did you do any research on other toy cameras, or cameras in general?

There was always a closet designer in me—I love the idea of design. Everything from furniture to buildings to items we use on a daily basis. What Bigshot allowed me to do more than develop technology was learn the process of design. We started from scratch. I sketched on paper. At first, I had a rice cake design, which was triangular, and then a circular clock design. It didn't take long for me to learn why most cameras are rectangular.

Bigshot has an ambitious goal: learning by building. You go to the website and learn about the science, the STEM aspect [science, technology, engineering, mathematics]. There are nine interactive chapters that can be read on

Bigshot entered the market in August 2013 and the sales have far surpassed my expectations. We have fought very hard to keep the price at $89 USD and we have primarily achieved that by selling online, mostly. There have also been interesting collaborations and partnerships. In Japan, Bigshot is one of the few products sold by SuperHeadz that is not made by the company. Google ran a Bigshot holiday program where for every camera purchased by a Google employee, another camera was donated.

In other interviews you've made it a point to say that the Bigshot is not a toy, but an educational tool. Obviously, users learn how a digital camera works through

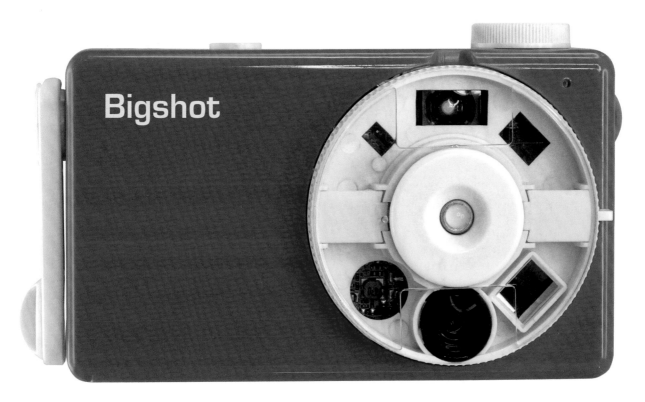

building one. But does the educational component end once the camera is made? What are your feelings about what the act of taking pictures can teach users, especially children and teenagers?

Once it is assembled you have a fully functioning digital camera—with it the storytelling and artistic component of the experience begins. You take pictures and then you can share your work. Bigshot blends the arts and the sciences and gives kids the opportunity to figure out what they like. There are wonderful robotics kits available, but you already need to have an interest in engineering to be drawn to such a kit. Bigshot draws a much wider

audience. Your kid might be drawn to the science aspect of it; mine may take to photography. It offers a broad and yet rich learning experience. It is meant to be playful, but it is not just a toy.

GAME BOY CAMERA

Manufactured in Japan for Nintendo. Year: 1998.

Focus	auto
Picture quality	0.014MP
Image size	256×224 (JPEG)
Memory	internal (30 images)

At the time of its release, the Game Boy camera was the world's smallest digital camera. Essentially a novelty accessory for the Game Boy portable gaming system, the Game Boy camera included various built-in mini games, some of which were hidden within the software. Unique was the rotating front-facing camera, which stored up to thirty images at a time. Setting options for shooting included Trick (mirror and zoom effects), Montage, Panorama, and Game Face (taking photos of your face for use in a built-in game).

To print, one had to purchase the Game Boy Printer, a thermal printer that produced grayscale images at a size of 1 in. × .875 in.

Five color variants were released: yellow, red, blue, green, and (in Japan only) purple. A limited gold version was available as a mail order offer in *Nintendo Power* magazine, to promote the N64 release of *The Legend of Zelda: Ocarina of Time*.

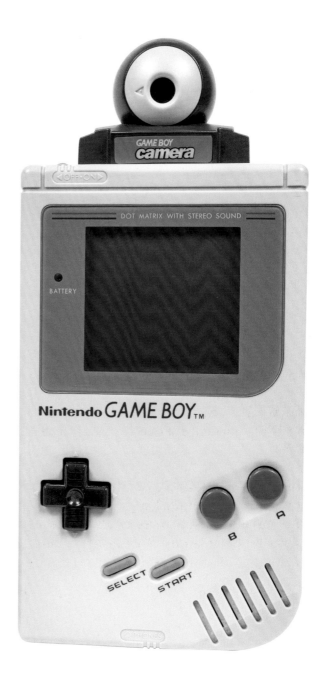

DREAMEYE FOR SEGA DREAMCAST

Manufactured in Japan for Sega. Year: 2000.

Focus	auto
Picture quality	0.3MP
Shutter speeds	1/10
Image size	640×480 (JPEG)
Memory	internal (31 images)

The Dreameye was a Japanese-only release for Sega's final video game console, the Dreamcast. Essentially a rudimentary webcam (it came with a stand and microphone headset), the Dreameye also detached for on-the-go still photos, storing up to thirty-one images at a time. It came bundled with photo editing software, *Visual Park*, for use on the Dreamcast.

BATMAN DIGITAL CAMERA

Manufactured in China for Kids Station Toys, Ltd. Year: 2005.

Focus	auto
Picture quality	1.3MP
Aperture	f/2.8, f/6.57
Focal distance	8cm to infinity
Memory	SD card

WWF SLAM CAM

Manufactured in China for Toymax. Year: 1999.

TRANSFORMERS AUTOBOT DIGITAL CAMERA

Manufactured in China for KIDdesigns, Inc. Year: 2009.

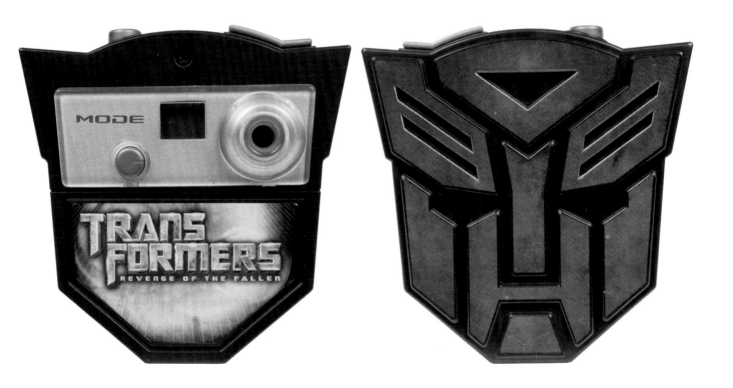

CHOCOLATE DONUT CAMERA

Manufactured in China for Geanee.

Focus	auto
Aperture	f/2.8, f/4.06
Shutter speeds	(electronic) 1/2 – 1/100
Picture quality	3MP
Image size	1536×1536 (JPEG)
Video size	640×480 (AVI)
Memory	MicroSD

Camera: Chocolate Donut.

AIROU TOY DIGITAL CAMERA

Manufactured in China for Capcom.

Focus	fixed/auto
Lens	6.5mm
Aperture	f/3.1
Focal distance	70cm to infinity
Picture quality	3MP
Image size	2048×1536 (JPEG)
Video size	640×480 (AVI)
Memory	MicroSD
Flash	built in

Airou (Felyne in the English version) is a cat-like humanoid character from Capcom's popular Japanese video game series *The Monster Hunter*.

SPONGEBOB MICRO DIGITAL CAMERA

Manufactured in China for NPower/Memorex.

Focus	auto
Picture quality	0.3MP
Image size	640×480 (JPEG)
Video size	640×480 (AVI)
Memory	8MB internal

LEGO DIGITAL CAMERA

Manufactured in China for Digital Blue. Year: 2011.

Focus	fixed
Picture quality	3MP
Image size	2048×1536 (JPEG)
Zoom	640×480 (AVI)
Memory	4x digital
Flash	built in

FURTHER READING

The following books were helpful with our research and provoked a great many ideas with regard to thinking about photography, culture, and toy cameras.

Bates, Michelle. *Plastic Cameras: Toying with Creativity* (Focal Press, 2010).

Baudelaire, Charles. "The Philosophy of Toys" (translated by Paul Keegan), from *Essays on Dolls* (London: Syrens, 1994).

Bonanos, Christopher. *Instant: The Story of Polaroid* (New York: Princeton Architectural Press, 2012).

Brayer, Elizabeth. *George Eastman: A Biography* (Rochester, NY: University of Rochester Press, 2012).

Dyer, Geoff. *The Ongoing Moment* (New York: Random House, 2005).

Featherstone, David. *The Diana Show: Pictures through a Plastic Lens* (Friends of Photography, 1980).

Hirsch, Robert. *Photographic Possibilities: The Expressive Use of Equipment, Ideas, Materials, and Processes* (Focal Press, 1991).

Hostetler, Lisa. *Street Seen: The Psychological Gesture in American Photography, 1940-1959* (Milwaukee, WI: Milwaukee Museum of Art and Munich: DelMonico/Prestel, 2009).

Marien, Mary Warner. *100 Ideas That Changed Photography* (London: Laurence King Publishing, 2012).

Sontag, Susan. *On Photography* (London: Penguin Modern Classics, 2008).

Wade, John. *Cameras in Disguise* (Buckinghamshire, UK: Shire Publications, 2005).

Wade, John. *From Daguerre to Digital: 150 Years of Classic Cameras* (Buckinghamshire, UK: Shire Publications, 2005).

Warren, Lynne. *Encyclopedia of Twentieth-Century Photography* (Routledge, 2005).

Westfall, Stephen. *James Castle/Walker Evans: Word-Play, Signs and Symbols* (New York: Knoedler & Company, 2006).

ACKNOWLEDGEMENTS / IMAGE CREDITS

The authors would like to thank the following people for their help and support during the process of putting together this book.

Along with all the interview subjects: Tom Bates and Christian Polt at Lomography; Christine So at Holga; and Alex Holbrook at The Impossible Project.

Photographers:
Remo Camerota • www.whitewallstudios.net
Jake Davis
Scott Livignale
Brian Scott Peterson • brianscottpeterson.com
Carlos Poveda
Alli Putnam
Eric Rechsteiner
David Tsai
VJ
John Williams
Lisa Wilkerson

J. K. Putnam for his skills and passion for the project—this book couldn't have been done without you.

Manami Okazaki for the answers to our questions.

Lissa Rivera for the Photoshop talent.

At Prestel: Ali Gitlow, Lincoln Dexter, Friederike Schirge.

All photographs of cameras by J.K. Putnam, with the following exceptions: page 7 courtesy of Carlos Poveda; page 15 courtesy John Williams; page 111, pages 118-121 courtesy of Holga; pages 126, 128-129, 134-135, 140, 143, 144-147, 149 (except for the Submarine), 153, 156, 160-161 courtesy of Lomography; pages 173, 178-179 courtesy of The Impossible Project; pages 182-187 courtesy of Brian Scott Peterson; pages 214-217, 219 courtesy of Fuuvi; page 222, pages 224-225 courtesy of Shree K. Nayar.

Credits for photographs shot with toy cameras:
Remo Camerota: 109, 131, 136-137
Jake Davis: 197
Scott Livignale: 93-95, 132-133, 151, 155, 157, 210-211
Brian Scott Peterson: 182-187
Alli Putnam: 200
J. K. Putnam: 25, 31, 37, 39, 59, 63, 75, 77, 79, 82, 85-87, 91-93, 117, 141, 159, 164-165, 191, 201, 202, 208, 233
Eric Rechsteiner: 104
Christopher D. Salyers: 74, 104-105, 112-113, 150, 174-175, 205
David Tsai: 195
VJ: 154
Lisa Wilkerson: 209

ABOUT THE AUTHORS / PHOTOGRAPHER

Christopher D. Salyers is a Brooklyn-based designer, toy camera collector, and author of numerous popular culture titles, including *Vending Machines: Coined Consumerism* and *Face Food Recipes*. His work has been featured in *Wired*, *The New York Times*, *Fast Company*, *Fader*, *Monocle*, TV Asahi, and Fox News. For more toy camera images, visit christopherdsalyers.com.

Buzz Poole has written about books, design, art, and culture for numerous outlets, including *Print*, *The Village Voice*, *The Believer*, *Los Angeles Review of Books*, *San Francisco Chronicle*, and *The Millions*. He is the author of the story collection *I Like to Keep My Troubles on the Windy Side of Things*; the *New Statesman* named his examination of unexpected iconography, *Madonna of the Toast*, one of 2007's Best Underground Books.

J. K. Putnam has been published in dozens of photography and design books including *CBGB: Decades of Graffiti*, *Decay*, and *Past Objects*. He travels as often as life affords him to capture images of the wild and distant places featured in his photographs. His collection spans five of the seven continents and contains pictures of both the natural and modern world. For more of his work visit jkputnamphotography.com.